CW01024923

BRISTOL IN 50 BUILDINGS

CYNTHIA STILES

AMBERLEY

Map contains Ordnance Survey data © Crown copyright and database right [2016]

This edition first published 2016

Amberley Publishing, The Hill, Stroud
Gloucestershire GL5 4EP

www.amberley-books.com

Copyright © Cynthia Stiles, 2016

The right of Cynthia Stiles to be identified as the Author of this work has been asserted in
accordance with the Copyrights, Designs and Patents Act 1988.

All rights reserved. No part of this book may be reprinted or reproduced or utilised in any form or
by any electronic, mechanical or other means, now known or hereafter invented, including
photocopying and recording, or in any information storage or retrieval system, without the
permission in writing from the Publishers.

British Library Cataloguing in Publication Data.
A catalogue record for this book is available from the British Library.

ISBN 978 1 4456 5005 0 (print)
ISBN 978 1 4456 5006 7 (ebook)

Typesetting and Origination by Amberley Publishing.
Printed in Great Britain.

Contents

Acknowledgements

Over the years I have read many books about Bristol's history and buildings, from scholarly tomes to popular guides. I have bought quite a few of them myself, but a fair number, as well as copies of the fascinating old local newspapers, I have accessed in the Bristol Reference Library, a resource for which I have always been grateful. I would like to thank the library staff for their unfailing helpfulness and interest.

My grateful thanks also go to my husband David and daughter Sharon for their assistance and patience while I have been compiling this book.

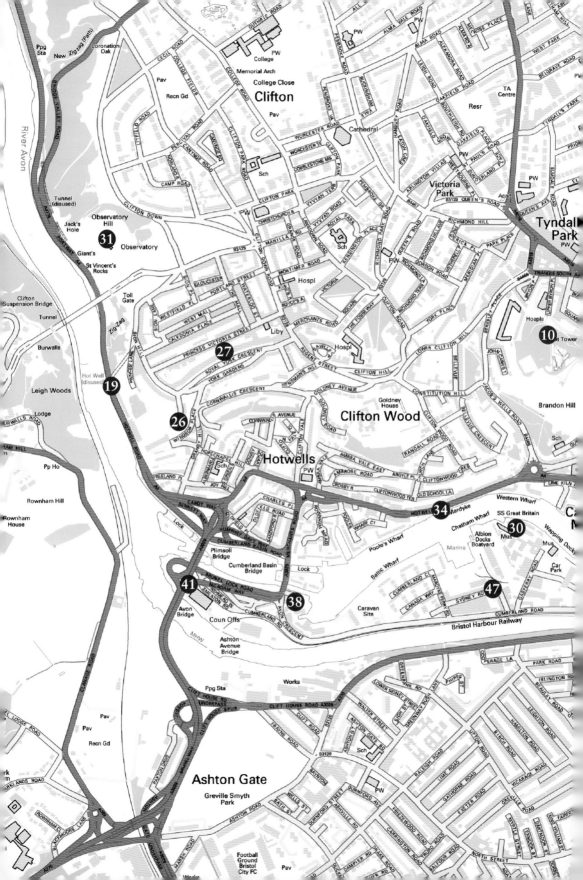

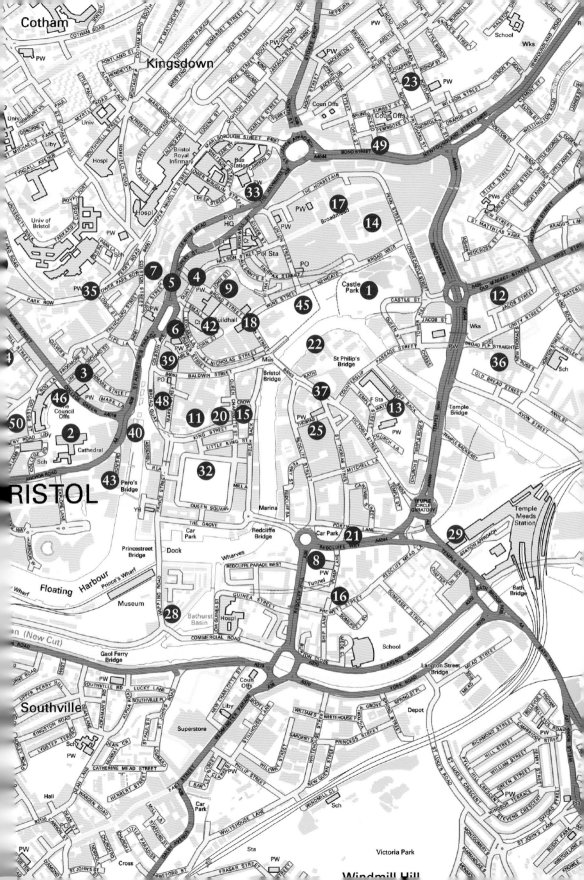

Introduction

How best to describe Bristol? To quote from the 1946 *Arrowsmith's Guide*: 'Bristol is anything but a static unchanging city. Her citizens have rarely allowed sentiment or love of antiquity to stand in the way of development.' This was written after the city had been ravaged by the wartime blitz and another book of a similar date questioned whether the Georgian squares and terraces, which had been built for a different age, should now be demolished or preserved.

Bristol had grown up in Saxon times on a piece of land between the rivers Avon and Frome. There were four main streets – High Street, Corn Street, Broad Street and Wine Street, but gradually other roads, alleys and courts were squeezed in. The gardens of the original large houses, courtyards of inns, spaces between workshops, all became filled with a warren of closely packed dwellings.

Mid-nineteenth century letters to the newspapers complained that it was wrong to try to improve the old city streets as they were too narrow, they should be pulled down and in fact from then on an increasing number of ancient buildings were ruthlessly destroyed in the name of street improvements. To be fair, the picturesque outside had often been squalid inside. Many old timbered houses, with little or no sanitation were occupied by up to ten families, as can be seen in the census returns of the time. Much had already been swept away long before the bombs came.

Then for years Bristol had bomb sites, as both money and building materials were in short supply. When better times came, people wanted new and not mended. The pleas for conservation were seen as anti-progressive, denying the city a place in the modern age. We have cause to be thankful for those who steadfastly kept protesting doggedly against demolition, though frequently defeated, until at last the tide had started to turn.

It is therefore not easy to walk round Bristol today and see its history laid out tidily before you, starting with the ancient buildings and moving consecutively through to modern ones in progression. As a result, the city is difficult to appreciate as a whole. These fifty buildings each highlight some stage in the development of Bristol. I do not claim it to be the definitive list and others might well choose different and equally valid examples, but I hope this may go some way to explain Bristol's history.

The 50 Buildings

1. Bristol Castle

The castle figures prominently on Bristol's coat of arms, yet little remains. But if you stand by the ferry landing in Castle Park and look up, you can imagine how such a building held a commanding position over the surrounding area.

There is no record of resistance to the Norman invaders by those who lived in Bristol, or even how many inhabitants there were at the time. Certainly William the Conqueror did not take any punitive measures, as he did elsewhere in the west of England. In fact a year after Harold died at the Battle of Hastings, when his vengeful sons came in ships from Ireland, the men of Bristol defended the town against them, rather than rallying in support.

A castle was built on the ridge by Geoffrey of Coutances before 1088, as he held the land from William the Conqueror. It was of the motte and bailey design, on a mound with a stone tower and defensive ditch. Geoffrey died in 1093, having been stripped of his lands after taking part in a rebellion against King William Rufus, the Conqueror's son. Bristol was then granted to Robert FitzHamon, who had stayed loyal to Rufus.

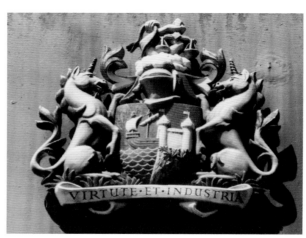

The arms of the City and County of Bristol featuring a ship and castle, which shows the importance of both in mediaeval times. The later grant of the crest and supporters was by Clarencieux, King of Arms in 1569.

FitzHamon's daughter and heiress was married off to Robert, Henry I's illegitimate son, who became Earl of Gloucester. Around 1135 Robert upgraded the castle and had a great keep built of Caen stone. The walls of the keep are reputed to have been twenty-five foot thick at the base and the building itself sixty feet by forty feet in size with four towers all equipped to defend it against assault.

Henry of Huntingdon wrote in his *Chronicle* that,

> In this castle was collected so numerous a band of knights and men at arms (I ought to call them freebooters and robbers) that it not only appeared vast and fearful to the beholders but also terrible and incredible. They were drawn together from different counties and districts, perfectly satisfied to serve a wealthy lord.

They obviously served Robert well during the twelfth-century anarchy, as he successfully held Bristol Castle for his half-sister Matilda when King Stephen besieged it. Then, in 1141, Stephen was imprisoned in it for a while, after he was captured at the Battle of Lincoln. Robert died of fever in 1147 and some forty years or so later, marriage to Robert's grandaughter brought the castle into the hands of Prince John. During the prince's revolt against his brother, Richard I, the constable of the castle had to stave off attacks by the king's army.

The turbulent times continued through the thirteenth century and during the Barons' War, in Henry III's reign, Prince Edward was besieged in the castle by the townsmen of Bristol who felt he had made overly heavy demands for supplies and upkeep. He managed to escape by night and the garrison surrendered a short while later. In 1265 Edward got his own back, however, by retaking the castle and imposing a huge fine.

By the 1600s the castle, little used now, was becoming ruinous. The area, with ramshackle houses inside its walls, known as Castle Precincts, was not part of the city of Bristol, so the corporation had no jurisdiction over it. Many of the people who inhabited it were roughs, toughs and undesirables. The corporation petitioned Charles I who, by charter, separated the Castle Precincts from the county of Gloucestershire and put it within the bounds, jurisdiction and authority of the mayor, sheriffs, coroners and justices of Bristol and in 1631 the castle itself was purchased.

But now came the Civil War. The castle was occupied by the Parliamentarians and some repairs were made to shore it up. Prince Rupert managed to take Bristol back on behalf of the king, although in his own turn had later to surrender it. Oliver Cromwell became Protector and the castle's fate was sealed as he ordered its destruction in December 1654.

After the castle was demolished, several streets of houses were built here, ensuring good rents for the corporation. By the nineteenth century the area had developed into the main shopping district of the city, but the odd piece of castle still lurked among the shops. In December 1936, Boots the Chemist bought premises containing vaulted chambers and a fragment of wall of the vestibule of the banqueting hall.

The Castle Street area was severely bombed during the Second World War. Afterwards, most of the buildings around here, repairable or not, were swept

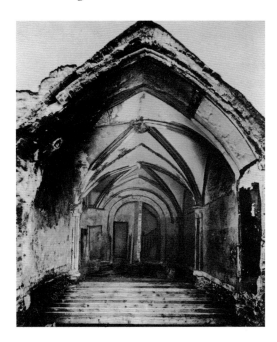

An old postcard showing Bristol Castle vaulted chambers. These are the remains of porches to the state rooms or King's Hall of the castle.

away in council planning schemes of the time. The vaulted chambers survived the destruction of the castle, survived the attack of the Luftwaffe and survived the post-war clearances. They're still here today, and can be glimpsed through the windows of a protective building at the far end of Castle Park.

2. Bristol Cathedral and the Abbey Gatehouse

When Robert Fitzharding, a wealthy and influential member of the Berkeley family, founded St Augustine's Abbey in 1142, little did he dream that centuries later its church would become Bristol Cathedral. Outside the town, on a ridge above the river, the twelfth-century abbey was home at first to just six canons under Abbot Richard and the church was not consecrated for another quarter century or so.

It didn't look much like what we see now, having a small nave and no towers. The Norman Chapter House, sturdy rather than lofty with chevron and zigzag moulding and arcading, gives a good idea of the style of the building. When the Elder Lady Chapel was built around 1215, much more elaborate carving was used.

The eastern end of the church and the choir were rebuilt around the early part of the fourteenth century and the central tower was completed around 1500. But the Norman nave that had been demolished at this time remained unrestored, so the church ended in a blank wall. It was the Victorians who added the west end with its two towers.

The fortunes of the abbey ebbed and flowed over the years. Abbot David was obviously well regarded by William Marshal, Earl of Pembroke and Regent of

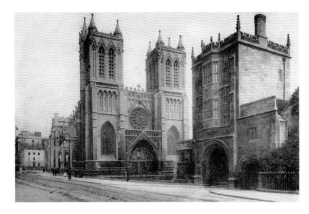

Bristol Cathedral and Abbey
Gatehouse from a postcard sent
1903. This gives a good view of
the two western towers which
were added to the cathedral
in the late nineteenth century,
adding considerably to its size.

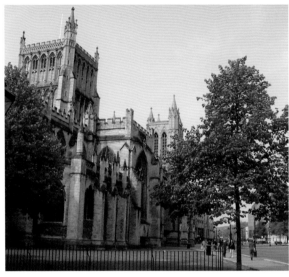

The Cathedral seen from the
opposite direction, showing
the central tower.

England, as he travelled to Ireland in 1218 to look into a dispute on the earl's
behalf. But David was later removed from office due to quarrels with his
subordinate canons. Sixty years later the monks were rebuked by the bishop
for bad behaviour with reports of drunken revels in the infirmary and a lack of
attention to meditation and prayer. They veered between being accused of living
too well, keeping hounds and spending time outside the precincts, to finding
themselves in a state of poverty and heavily in debt.

Some abbots were spiritual, some progressive, others just weak and inefficient,
leading to periods of harmony punctuated by disorder. But as the town grew, so
did conflict with the corporation over certain long-held rights, including that
of sanctuary offered to criminals, plus a refusal to pay taxes. More than once
in the early years of the sixteenth century there were flare-up incidents, ending
in violence between the two parties.

In 1540, at the time of the Reformation, the abbot was forced to surrender the
abbey to the King. He begged not to be thrown out on to the streets, and in fact

was eventually given a pension of £80 a year. The see of Bristol was formed and Paul Bush, who was Henry VIII's chaplain, was made the first bishop. He married, which was considered a large black mark against him when Mary Tudor ascended the throne, and although his wife died he was still forced to resign. His effigy can be seen in the north choir aisle with a cadaver version beneath.

The arch, to the right of the cathedral, originally led into the abbot's courtyard, where there were household buildings, granaries, bakehouses, brewhouses and stables. In the late nineteenth century, the lower portion of the gateway was still in good condition, but the decaying upper part was restored. To fill the niches on the south side, sculptures of four abbots, Newland, Elyott, Knowle and Snow, were made by Charles Pibworth, a Bristol-born artist, in 1914.

3. Lord Mayor's Chapel

It's known now as the Lord Mayor's Chapel but it started life as St Mark's Church. Back in 1220, when College Green was a meadow of Billeswick below Brandon Hill, Maurice de Gaunt founded the Hospital of St Mark there as an almonry of the adjacent St Augustine's Abbey. When Maurice died ten years later, his nephew Robert de Gournay took away its dependence on the abbey and built a church for the St Mark's community, who had taken vows of continence, obedience and abdication of property. There was a master, six clerks, three chaplains, five lay brothers and twelve scholars. They gave food and help daily to 100 people.

St Mark's and the abbey did not live in harmony after that. Probably the abbot was annoyed at the hospital's new independence. Quarrels flared up about the use of the green. It was part of the abbey's lands but St Mark's claimed they had rights

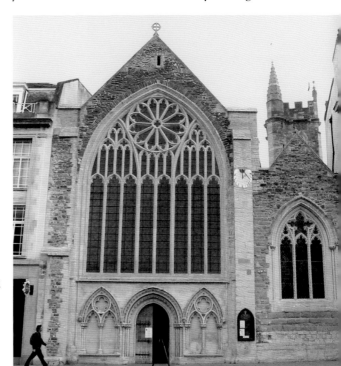

The Lord Mayor's Chapel seen from College Green. The original chapel was small and aisleless but was later extended. The west front is dominated by its large stained-glass window.

of burial and sheep pasturage on it. The bishop had to be called upon in 1259 to settle the disputes.

The first part of St Mark's history was brought to an end by the Dissolution of the Monasteries in the mid-1500s. The friars were pensioned off, silver plate went to the king and the Corporation of Bristol bought the land and buildings. These were used for the newly founded school which became known as Queen Elizabeth's Hospital.

In the 1680s religious persecution was happening across the Channel and French Protestant Huguenots fled from their homes to seek safety in England. Merchants, sailors and weavers, they made their way to ports like Bristol and London. They were offered St Mark's as a place to worship and used the chapel from 1687 to 1721.

By the 1720s only the chapel remained of the hospital buildings, and even that was in poor repair. Around this time the mayor fell out with the cathedral authorities and decided to repair St Mark's, and use it as a civic chapel. It then became known as the Mayor's Chapel, to be changed to the Lord Mayor's Chapel after Queen Victoria bestowed the title on Sir Herbert Ashman. Bristol and London are the only English cities to have a Lord Mayor.

So small compared with the cathedral, with its red sandstone tower almost hidden to passers-by, this is a building which has weathered the years. The interior reflects the various stages of the church's life. There are stone effigies of knights, mediaeval carvings, a Tudor ceiling, eighteenth-century hatchments, nineteenth-century choir stalls and some beautiful stained glass.

The red sandstone tower of St Mark's was completed in 1487, according to a mason's inscription on it.

4. St John's Gateway

Although the rivers Avon and Frome provided some natural protection, strong walls were built quite early to tightly encircle the town for added defence. These walls were pierced by several gateways where tolls were paid to bring in goods for sale and which were barred up at night. As the town expanded, the inner walls were superseded by an outer set.

When Henry VII visited Bristol on his great progress round the kingdom following his victory over Richard III, he was welcomed at the walls with verse-laden speeches, telling of the legendary founding of Bristol by King Brennus. This probably bored the new monarch rigid, but he had to endure several more similar outpourings, including one at St John's Gateway, the north gate, that included a pageant by 'mayden children'.

The spire of St John's church stands atop the arched gateway. The origins of this church go back at least to the twelfth century, but it was wholly rebuilt on a section of the town wall in the late 1300s. Known as St John on the Wall, the new building owed its existence to the wealth of three-times Mayor of Bristol, Walter Frampton. It may be a simple aisle-less church but once through the narrow doorway and up the steps, the ceiling height and large windows make it seem surprisingly spacious and light. The crypt is unusual in being at ground level. No longer used for services, the church is in the care of the Churches Conservation Trust.

The gateway itself bears figures said to be of Brennus and his brother Bellinus but possibly of real English monarchs, their actual identity lost down the years. The statues were repaired in 2006/7. Only the central archway is original, the two side passages were made for pedestrians in the nineteenth century, to keep them

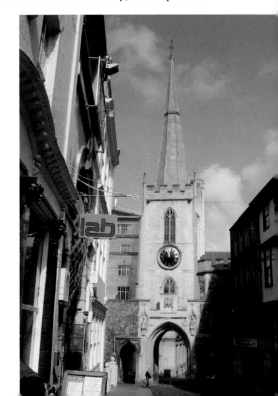

Looking down Broad Street towards St John's Gateway. Originally four of the city gateways had churches over them, but the other gateways have been demolished over the years.

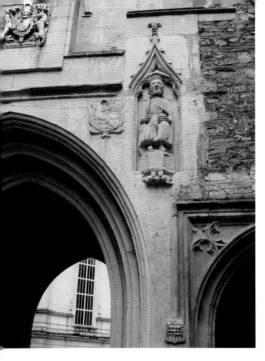

The right-hand statue after refurbishment. Also visible carved over the top of the arch is the Stuart royal arms.

safe from the wheeled traffic which was only forbidden in the latter part of the twentieth century.

The walls acted as a deterrent against attack as late as the seventeenth century. In 1495, a few years after Henry VII's visit, a horde of Cornish rebels demanded entrance to the town and were met with a curt refusal. In 1549 a rebellion connected to religious changes, against the enclosure of monastery lands which had been bought up and the consequent cessation of help to the poor, resulted in the mayor ordering the walls to be manned with armed defenders and the gates repaired. The rebels were captured after four days of skirmishes in the Marsh. Just under a hundred years later, during the Civil War, Royalist plotters planned to overpower the Roundhead guards of St John's gateway and imprison them in the crypt, then open the gates for Prince Rupert's army, but were discovered and the ringleaders hanged.

St John's Conduit is now to be found outside the gateway but it was only moved there in 1827, replacing a conduit house on the other side of the church. Piped from a spring on Brandon Hill, the water was once a vital supply to the inhabitants of the houses in this part of the city, where wells were often contaminated.

5. St Bartholomew's Hospital

St Bartholomew's Hospital was built outside the wall just across from St John's Gate, on the north bank of the Frome. All you can see nowadays are the early English gateway, arches and capitals of the Porter's Lodge. Originally there was a whole range of buildings and rooms including hall, guest house, kitchen, pantry, larder, bakehouse and granary.

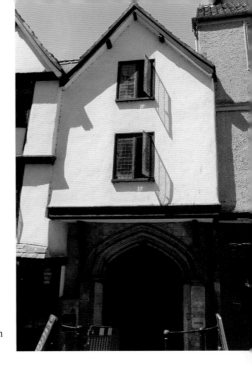

St Bartholomew's Hospital frontage with its Early English arch at the foot of Christmas Steps.

In the thirteenth century Bristol was becoming more prosperous and wealth was being used to endow religious foundations to carry out good works, as a fundamental teaching of the church was the importance of mercy and charity. John la Warre founded St Bartholomew's around 1240 and put it under the charge of a master supervising an enclave of religious men and women to care for the sick and needy who came for aid.

This was no tranquil retreat. It was near the busy, noisy quayside, a well-used gateway to the city and a place where clothes washing was done. Being so close to the Frome, there were problems with flooding. Shockingly, in 1285 the Master of that time was murdered by two chaplains from St James' Priory, a short distance away. In the fourteenth century there were quarrels over who should be Master and a prioress named Eleanor expelled all the men. This was resolved but there were further disputes. Often the equipment was quite rudimentary and in poor repair and the buildings became more and more dilapidated.

In 1531, Henry VIII declared himself head of the Church in England and one of the royal desires was that charitable money previously given to monks and priests should be converted into erecting grammar schools. Lord la Warre transferred the St Bartholomew's land and buildings to a Bristol merchant, Robert Thorne. Thorne died a few months later and bequeathed money for a grammar school, which was then founded by his brother Nicholas. Nicholas, in his will of 1546, also left money for the school, as well as books, maps and astronomical instruments. Bristol Grammar School occupied the premises in increasingly unsatisfactory conditions until 1767.

It was stated there were now too many pupils for the St Bartholomew's site and the corporation was persuaded that the school should exchange premises with Queen Elizabeth's Hospital, another endowed school, whose buildings at

Inside the porch of St Bartholomew's.

College Green had been improved and enlarged. The boys of QEH stayed for eighty years before they got some justice and moved to a purpose-built school on Brandon Hill.

Once more St Bartholomew's underwent changes of use. First it was used by a cooper, then made into a scheme of model dwellings for the working classes. When that fell through, it was put to a series of industrial uses, latterly a printing company, before being converted into offices in the late 1970s.

6. St Stephen's Church

The growth of Bristol as a port during the early thirteenth century led to the vexing problem of lack of space for loading and unloading cargoes, which was becoming a more time-consuming process. As well as small boats plying a coastal trade to Wales and Ireland, there were now larger ships capable of withstanding the open water, carrying cargoes of wine from France and fruit, almonds and oil from Spain and Portugal.

The answer in the 1240s was to divert the course of the river Frome through Canon's Marsh, forming the new wider, deeper channel, below the abbey and thus called St Augustine's Reach, which was then lined with stone quays. It was a huge job, around half a mile long, 1,200 feet wide, eighteen feet deep and which took seven years to complete. Soon Bristol was reckoned second only to London in the number of its ships.

An area of land was reclaimed outside the old town wall, where the Frome used to flow. After a while new houses were built, as well as St Stephen's Church which replaced an earlier building erected by monks from the abbey at Glastonbury. The church may seem rather cramped in its small churchyard but was always closely surrounded by narrow lanes of houses.

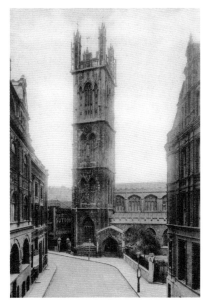

Old postcard showing St Stephen's church and
nearby buildings.

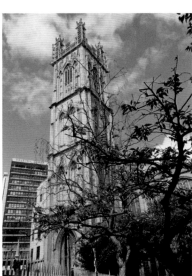

The four-stage tower of St Stephen's church.
To reach the top requires climbing a large number
of steps but gives a marvellous view.

The 152-foot tower and great west window were paid for by John Shipward,
one of the merchants who lived nearby. In his will of 1473, he left money to
provide missals, a chalice and vestments for the church but also a sum for
distributing bedclothes among the poor householders of the parish. It's unusual to
know the names of the skilled men who built the mediaeval churches, but William
Wycestre, who wrote a description of Bristol in the 1480s, speaks of the mason
called Benedict (Benet) Crosse and his 'ingenious work' on the porch.

In late November 1703 a hurricane blew across southern England, wreaking
havoc and causing a great tide which flooded the Bristol cellars where the

merchants' goods were stored. Not only did water pour into the church, but also three pinnacles were destroyed by the wind. The tower has undergone several bouts of restoration, the latest being completed in 1972, while war damage to the west window had already been repaired in 1951.

There's sadly no effigy of John Shipward inside. In spite of destruction inflicted on the interior at the time of the Reformation, Edmund Blanket and his wife still lie serenely on their tomb, hands piously together in prayer while Sir George Snygge, resplendently dressed in judge's robes, looks outwards, holding a scroll like those he would have consulted as Recorder of Bristol, 500 years ago. There is also a memorial to Martin Pring who sailed to America and discovered Plymouth Harbour in 1603.

7. Chapel of the Three Kings of Cologne

Christmas Steps was originally a very steep, muddy and narrow lane. It led up from the Frome Bridge and was a natural cut-through to St Michael's church and the road to Horfield, Aust Ferry and thence to Wales. A wealthy wine merchant named Jonathan Blackwell, who had been Sheriff of Bristol in 1652, came up with the money to improve 'the way up Stipe-hill' by putting in steps. It was given the name of Queen Street which was used until well into the nineteenth century. Then it started becoming known as Christmas Steps, as a hundred years ago looking down the steps would have given a view along Christmas Street to the spire of St John's. Changes in road layout and the building of Electricity House have taken away the visual link to the old city.

At the top of Christmas Steps, by the plaque on which details of Blackwell's benevolence are carved, is the Chapel of the Three Kings of Cologne. John Foster, who had been Mayor of Bristol back in the fifteenth century, had also wanted

The view down Christmas Steps.

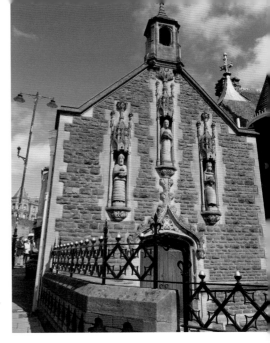

Chapel of the Three Kings of Cologne, Colston Street.
The frontage originally held a large window which
was removed during nineteenth-century renovations.

to do good works and for that purpose bought some land from the nunnery of
St Mary which stood just above the hill. On his land he declared he would build
an almshouse and a chapel where a priest on certain days would sing mass for the
thirteen inhabitants. The priest was also to sing mass in the chapel for twelve years
from Foster's death, which occurred in 1492, towards the salvation of his soul.

The dedication of the chapel is unusual and has led people to speculate
that Foster had visited Cologne and seen the shrine to the Three Kings in
the cathedral there. Merchants did travel widely in the Middle Ages and there
were pilgrimages to that shrine. Foster was connected with the Icelandic fish
trade, yet there is no evidence he ever went there, let alone Cologne or even
anywhere in Europe. However, the Three Kings were invoked in some mediaeval
prayers said before going on a journey, which may have had particular
significance for a merchant.

The chapel is only thirty-six feet by ninety feet and in the Perpendicular style;
when the almshouses were rebuilt in the nineteenth century, the architect, another
John Foster, matched their style to it. The front has three decorated niches which
were inserted when an old window was removed during the rebuilding work.
The sculptures which fill them are modern, by Ernest Pascoe, carved when the
buildings were restored once more in the 1960s and above the tracery of the
centre figure is a star.

8. St Mary Redcliffe

Across the other side of the Avon, a low cliff of red sandstone overlooked Bristol's
walled town and here a settlement grew up. The Lords of Berkeley, who owned the
manor of Bedminster, considered that this Redcliffe came under their jurisdiction.

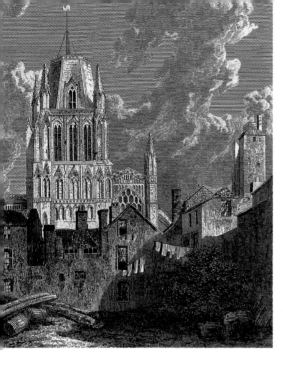

West end of St Mary Redcliffe from Redcliffe Back with old houses clustered nearby, early nineteenth century (Bristol Reference Library).

The burgesses of Bristol considered that Redcliffe was in their harbour area and shared its benefits, therefore should be under their control.

It was a bitter feud. In the early 1300s, when young Maurice of Berkeley was in Scotland with the King, a sizeable group of Bristol men got fired up, marched on his manor house at Bedminster and ransacked it. They were most probably really out to release a man called Robert of Cornwall, who lived in Bristol and had been seized by Maurice's bailiffs on a murder charge, but they carried off a vast amount of booty too. Berkeley complained to the king, the Bristol burgesses counter-claimed that their ships had been damaged.

But in 1373 the county of Bristol was incorporated by charter of Edward III. As Redcliffe was now included within the county area, the wall enclosing it became part of the city wall of Bristol. Excavations in 1980 near Redcliffe Backs found a section of wall about eight feet thick, built of local Pennant sandstone.

The story of the beautiful church of St Mary Redcliffe is one of highs and lows. A church was first built here some time before 1207, the year permission for a water conduit was granted to it. By 1246, there is a record of this church being entirely rebuilt. Then around 1300, Simon de Burton, three times mayor of Bristol, apparently lavished money on it, as the Mayor's Calendar states that merchant William Canynges rebuilt the church three quarters of a century afterwards, on de Burton's foundations.

The spire fell in 1455, during a great thunderstorm. The debris seems to have smashed into the nave as this was reconstructed by Canynge's grandson, also named William, who was responsible for more extensive rebuilding of the church. The spire, however, was not repaired and remained in a strange truncated state.

During the Civil War artillery was mounted on the roof during the first siege and it was a key defensive point. The Royalists were given specific orders to capture it

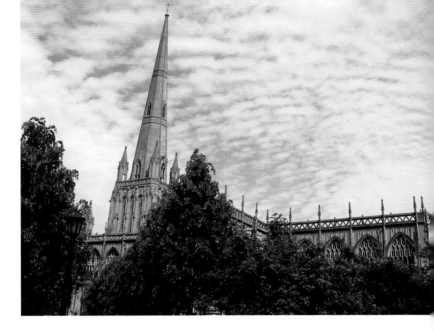

St Mary Redcliffe as it looks today with restored spire.

and most of the fragile stained glass was a casualty. During the eighteenth century the inside of the church was refitted in a Baroque style.

The area around the church became a centre for industrial activity and by the 1840s there were eighty-six hovels clustered close to the walls. These were destroyed and Phippen Street built. Years of smoke and acid rain had taken their toll on the masonry and the architect George Godwin reported, 'The deplorable condition of the building must distress every lover of ancient architecture. It is a crumbling ruin, the parapets falling, the walls splitting and the spirets on the tower so disrupted and decaying as to threaten some serious catastrophe.' It then took twenty-four years of fund-raising and restoration before the spire was rebuilt in 1872 and walls, buttresses and tracery were repaired.

One only has to look at the tramline embedded in the churchyard turf by the nearby explosion of a wartime bomb, to realise how close St Mary Redcliffe came to meeting the fate of other Bristol churches. But nearly £9,000 worth of damage to masonry, glass and the organ, was carried out by a young soldier who deliberately set fire to the vestry one evening in 1942. Fortunately the vicar noticed and managed to summon the fire brigade before the flames spread any further. It would have been truly tragic to have lost the history that is within St Mary Redcliffe.

9. Tailors' Court

In the Middle Ages you couldn't just walk into a town like Bristol and start up a business. Trades were strictly controlled by the guilds, determining prices and standards. It started with an apprenticeship, often at a very young age and miles away from their home town to a master who agreed to train a boy for a period of years, with board and lodging provided and a payment

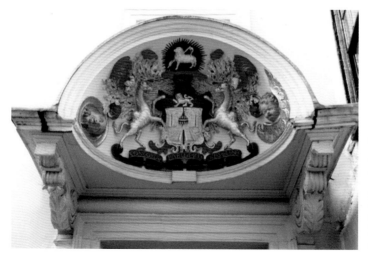

The decorated shell hood over the entrance door. John the Baptist's head on the platter can be seen at the left-hand side of the work.

only at the end of that time. Though a few were apprenticed to their parents, for the rest it could be a hard life, closely supervised and restricted by rules. Serving a seven-year successful apprenticeship to a burgess of the town was one of the ways to become a freeman, a necessary step to ever having any influence in civic policies, to be able to elect officers, vote for members of parliament or gain access to charities that had been set up.

The first charter of the Tailors' Guild was granted by Richard II when they were known as the fraternity of St John the Baptist and there was a strong religious influence on the ceremonial activities. In the reign of Elizabeth I the guild was remodelled and styled as a society and by then had the largest proportion of the apprentices in the city indentured to it. The hall at Tailors' Court, where the guild held their meetings, dates from 1740 but it's more than likely that the shell hood was reused from an earlier hall in the same place. It shows the attributes of St John and one can imagine that a deep sense of tradition would have led to it being retained.

However, tradition was being challenged and less than half a century later a tailor came to Bristol and set up his business without even applying to join the Merchant Tailors, who took their grievance to court. Unfortunately the judge who checked out their charter came to the conclusion that they had not fulfilled the provisions as a trade guild contained in it. As a result the Merchant Tailors stated that they would admit no further members and carried on with dwindling numbers until Arthur Palmer and Isaac Amos were the last two remaining. Even after Palmer died, Isaac stuck it out to the bitter end, appointing himself as master, which gave him an allowance, and arranging meetings which only he attended, until he died in 1824, thus bringing the whole sorry affair to a close.

At this time the court contained a counting house, warehouse and cellar. In 1831, there was a lock up for debtors and later it was used for a variety of political purposes such as the anti-Corn League, Liberal Association and Complete Suffrage movements and as a Temperance Hall during the latter part of the century.

10. Cabot Tower

Hundreds of people attended the opening of the Cabot Tower on a sweltering day in September 1898, but how many would have watched the mariner John Cabot sail out of Bristol in *The Matthew*, on a speculative voyage across the Atlantic four centuries before? Cabot had been born in Genoa, then lived in Venice before coming to England in search of financial backers for his venture. He found them in Bristol; men who had heard tales of the lands to the west, were looking for new markets and were lured by the thoughts of profits from cargoes of silks, spices and exotic woods.

Cabot was granted letters-patent by Henry VII for 'navigating to all parts, countries, and seas of the east, west, and north, under our banners, flags, and ensigns, with five ships or vessels of what burden or quality soever they be'. In the 50-ton *Matthew*, with a crew of about twenty, he navigated to and made landfall in Newfoundland in North America, although he thought it was part of Asia, and for this he was paid a pension by the king.

Nowadays we see this as a landmark voyage, but the Bristol merchants of the time may not have appreciated what they got in return for their money. After all, Cabot did not bring back the luxuries they hoped for. However, it set the stage for the future exploration and colonisation of the lands to the west and the great amount of trade between Bristol and America.

Cabot Tower which stands at the top of 250-foot-high Brandon Hill was designed by Bristol architect William Venn Gough and its construction paid for by public subscription. The tower is principally made of red sandstone with dressings of cream-coloured Bath stone. Inside there is a circular staircase to the first level and a spiral staircase to the second level where windows give panoramic views over the city and beyond.

Brandon Hill now has gardens and trees and is a pleasant place to spend time. Hundreds of years ago it was considered bleak enough for a hermitage. The underlying rock is millstone grit which must have been tough on those who dug

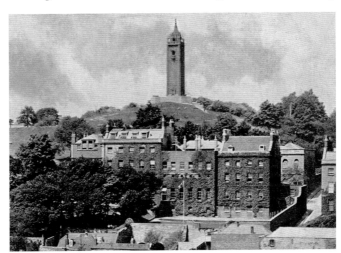

Cabot Tower, standing out very starkly on Brandon Hill from a postcard used in 1905.

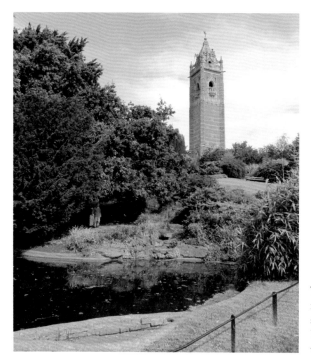

Trees, plants and a pool
now enhance Cabot Tower's
surroundings which have
become a haven for wildlife as
well as wild flowers.

defensive ditches there during the Civil War. The small fort that was built there, on
the order of Charles I, was enlarged to forty-five yards by thirty-five yards wide
with six guns in 1644 by Prince Rupert but it didn't save him from being defeated
by the Parliamentarians.

11. Merchant Venturers' Almshouses

The almshouses were erected for poor and disabled mariners in the seventeenth century
by the Society of Merchant Venturers. Way back in 1493 there had been a Guild of
Mariners who bought a parcel of land, 203 foot by sixty, just outside the town wall,
by a tower. On this they built a chapel to St Clement and they had almshouses nearby.
After the Reformation the guild was dissolved and in 1552 the Society of Merchant
Venturers was incorporated, taking over responsibility for the almshouses.

Originally nineteen places had been available, but at the end of the seventeenth
century the almshouses were rebuilt round a courtyard so an extra twelve
mariners and widows could be accommodated, while pensions and loans were
provided for others who had suffered illness or injury during their time at sea. The
old chapel, with the altar removed, was used for the society's meetings but their
100 or so members found it increasingly unsatisfactory, so built a proper hall on
the foundations in 1701 at the end of Marsh Street.

The Merchant Venturers have had a formidable influence in the city. The
members, often closely linked by their family connections, held key civic positions

The almshouses as they look today. An old poem about the seamen's gratitude is on the board above the doorway.

as mayors, sheriffs, aldermen and MPs, acquiring much land and property. They regulated imports and exports, checked on the competence of pilots, dealt with obstacles to navigation, expanded quays, set up new cranes, enforced rules about porters and financed voyages of exploration. The burgeoning trade with the American colonies brought sugar, tobacco and rum into the port, goods increasingly bought with the profits from cargoes of slaves to work the plantations.

The Merchant Venturers administered charities for Bristol seamen. During the seventeenth century they provided money to ransom sailors captured by the Turks, in the eighteenth century for free schools for mariners' children and since the beginning of the society for the upkeep of almshouses.

Only the north, east and part of the south side of the almshouse courtyard complex have survived due to bombing in the Second World War, which also demolished the Merchants' Hall adjoining. The Hall was never rebuilt, the society moving to premises on the Promenade, Clifton. The almshouses were considered unsuitable for twenty-first-century elderly care and a new, larger, purpose-built retirement home for older people was constructed elsewhere where the Merchant Venturers are trustees of the charity. The old almshouses are now private apartments, no longer home to the seamen who could say, according to the painted board on the wall:

Free from all storms, the tempest and the rage,
Of billows, we securely spend our age.

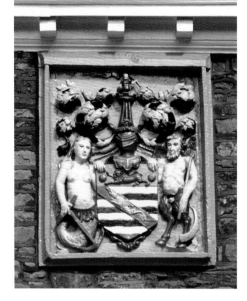

A carving of the Society of Merchant Venturers' coat of arms.

12. The Stag & Hounds, Old Market

The Stag & Hounds, with its pillared portico over the pavement is one of several old houses in Old Market. Tradition says it was built on the site where the Pie Powder court was originally held in the open air and the activities were then transferred to it. The court was certainly in operation in the market for hundreds of years.

In the fifteenth-century Old Market Street was described as broad and stone paved, beginning at a tall cross near the ditch of the castle. It's still as broad but much shorter nowadays, due to modern road development. This was the marketplace outside the walls, where produce was sold by local country dwellers and fairs, granted by royal charter, were held.

Under English law towns could hold a special temporary court at fair time to deal with disputes between merchants, accusations of theft, and acts of violence. Called Piepoudre or Pie Powder, from a derogatory old French word for pedlar or vagabond, these courts dispensed swift judgement because those involved in a case were visitors, likely to be soon off and away and out of jurisdiction. The court at Old Market was held for fourteen days commencing the last day of September, possibly because of a mediaeval Michaelmas Fair.

It was the custom for the new mayor and others appointed to go, ceremonially robed, in procession to the Guildhall, take their oaths and send a bailiff to keep the market court. The usual court held by the mayor in the Tolzey was discontinued for a fortnight and the sergeant at mace made a proclamation that court would be held at this place in Old Market. It promised 'cheap and speedy justice and redress of grievance', before the criminal could abscond. The opening was accompanied by a feast of toasted cheese washed down with potent metheglin, which could lead to rowdiness.

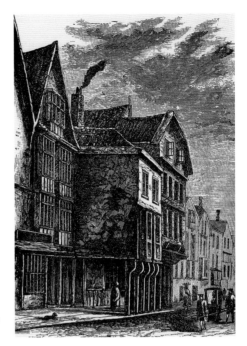

The Stag & Hounds in the late eighteenth century, from an old print. To the right can be seen the houses of the part of Old Market that has been demolished.

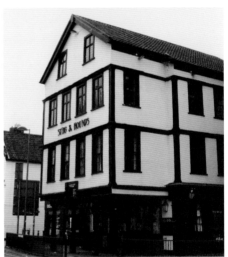

The Stag & Hounds today. It stands very close to a large roundabout system.

By the 1830s any case brought would be then taken to the last sitting of the Tolzey Court on 15 October and could be tried by jury before the Recorder in the Assizes, the following week. It was most often used for the recovery of debts, one case in 1861 being by a smith and farrier called Prewett against his attorney whom he claimed had failed to get him money from a debtor. Although the alcohol-fuelled feast was discontinued in 1870, a very short opening ceremony attended only by the clerk of the court and a sergeant at mace was still held until 1973, when the Courts of Justice Act brought Pie Powder to an end.

13. Temple Church

Cloth was Bristol's main export in mediaeval times, sent to Gascony, Aquitaine, Portugal and Ireland and great bales of it were produced by the weavers of the Temple district. The area was named after the Knights Templar who had built an oval church dedicated to the Holy Cross here, on marshy land given to them by Robert of Gloucester. The order was suppressed in 1312 and the Knights Hospitaller took over, replacing the earlier church with a rectangular one.

Then in 1395 Bernard Obelly and Reginald Taylor, woollen merchants, gave money to add a tower, but the workmen failed to lay adequate foundations for the ground conditions and it gradually settled to one side. In spite of now having a dramatically leaning tower, they put their faith in underpinning and added another two storeys in the mid-fifteenth century.

The days of weaving glory were gone but the tower's fame spread over the years. One observer commented that the church 'seemeth shaken by an earthquake'. A favourite party trick was to slide a stone into the crack between the two parts of the building and then ring the bells, so the stone was crushed to powder, as was demonstrated to the Duke of Norfolk in 1568.

Before the Reformation the church was notorious for clashes with the Bristol authorities about giving sanctuary to miscreants and therefore cheating them of administering justice. Vicars in later years were a mixed bunch. Jacob Brent was implicated in the plot to open the gates of Bristol to the Cavaliers in the Civil War, while the rather puritanical Arthur Bedford was the author of a pamphlet in 1706 entitled *The Evil and Danger of Stage Plays*. Samuel Curtis who died in 1739 was obviously less outspoken, described as inoffensive, though very gouty, but he had a diligent curate.

Temple Church from an early twentieth-century postcard.

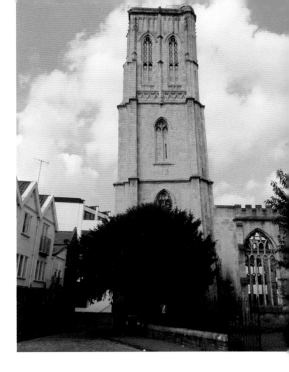

The leaning tower today, 5 feet out of true at the base but still proudly standing.

Henry Becher held the living of two other churches. His father had been mayor of Bristol and perhaps for that reason Becher was made chaplain to Frederick, Prince of Wales on a visit to the city in 1738. His successor, Thomas Jones MA, was tutor to the Free School. John Price in 1753, was noted as being worthy and a good reader of prayers. Alexander Catcott, author, geologist and theologian and apparently an excellent parish priest, died in 1779 and was replaced by Joseph Easterbrook, a friend of Wesley, who allowed him to preach in the church. Fountain Elwin held the living for over half a century from 1816, but by then the vicarage had become 'scarcely inhabitable due to manufactories carried on in the vicinity'.

This led to a restoration of the church in 1873 but when bombs fell in the Second World War, 700 years after its foundation, the building exploded into flames and was gutted. However, the leaning tower withstood the bombardment and is still a curiosity today.

14. Quakers Friars

The confusing name came about because the site was used firstly by friars and much later by Quakers. Dominican or black friars built a substantial church and living accommodation here back in the early days of the thirteenth century. Unlike the monks, the friars did not live in a closeted world of prayer and meditation; they preached to large congregations and went among the people of the town. Came the Dissolution and the land and buildings were granted by the king to William Chester, Mayor of Bristol, but the place was still known as the Friars.

By the middle of the seventeenth century, the friary remains had passed into the hands of Dennis Hollister, a grocer who was MP for Somerset in the 1653

Barebones Parliament and an early Quaker convert. At the time of the restoration of Charles II in 1660, there were many Quakers in Bristol, reportedly holding meetings of 1,000 to 2,000 people. Nine years later they had built a chapel on part of the Friars site but it was a time of great religious intolerance and they were not only harshly fined for Non-attendance at the parish church but also imprisoned and their meeting houses were boarded up.

In 1689, the year after the accession of William and Mary, the Act of Toleration was introduced, which allowed Non-conformist places of worship, though they had to be licensed. William Penn, the famous Quaker, came to live in Bristol for a couple of years in the late 1690s. His father, an influential admiral, had been born in the city and was buried in St Mary Redcliffe. William worshipped at

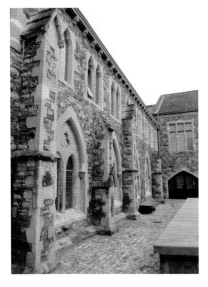

Part of the old Dominican friary buildings at Quakers Friars.

The eighteenth-century Meeting House, by George Tully, now used as a restaurant.

the Quakers Friars meeting house, where he married his second wife, Hannah Callowhill. Several of the Quaker community lent money to him for his activities in North America.

The meeting house was rebuilt in 1747 and the date is inscribed over the door. In 1845, the Cutlers' and Bakers' halls were purchased by the Quakers for use as a Sunday school, and later in the century a new hall was added for a week-day school.

The Quakers had an important influence on Bristol trade and commerce. They maintained a tradition of hard work, fair dealing and the importance of trade and industry as a form of service to the community. One of these was Robert Charleton who ran a pin-making factory employing about 110 women and girls and fifty men and boys.

Much better known is Joseph Fry, who trained as an apothecary, but began to sell chocolate, after claims of its health-giving properties. Cocoa and chocolate soon became popular and the lucrative business expanded under the leadership of his son, Joseph Storrs Fry. Family involvement in the firm continued as the number of factories in central Bristol increased and their delicious products were sold all over the world. Production was moved to Somerdale, near Keynsham after the First World War and Fry's merged with Cadbury's.

With the construction of Broadmead shopping centre, the Quakers Friars complex was left enclosed by the unattractive backs of shops and a car park. Yet this was the site featured in many wedding photographs as the Quakers moved out and the building was used as Bristol's register office from 1953 to 2006. The development of Cabot Circus has provided better surroundings for this interesting survival.

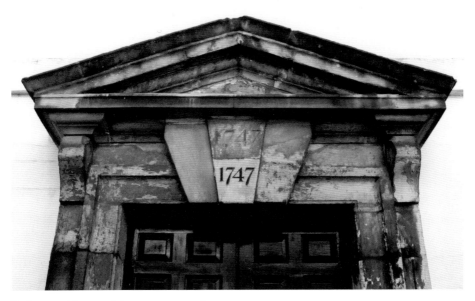

Pediment with carved date at entrance door.

15. The Llandoger Trow

If you'd come to Welsh Back a couple of hundred years ago, you'd have seen large flat-bottomed boats known as trows tying up here to unload their cargoes, after sailing in from Wales. One of the places they sailed from was Llandogo on the Wye. The Llandoger Trow is very conveniently just around the corner from Welsh Back in King Street and the first owner was almost certainly involved in the trading. It is said that he was a Captain Hawkins and he probably used the inn as a base for the Bristol end of the business, before retiring here.

The timber-framed buildings date from the seventeenth century, just after the restoration of Charles II, which had brought about a change from the previous dour, austere decades. There was a row of five houses, with the original inn at the right. The two houses that stood at the end of the street were destroyed by bombing during the Second World War and the others were incorporated into the Llandoger's premises in the 1960s.

The Llandoger lays claim to a couple of literary associations. Tradition states that it was the inspiration for the Admiral Benbow of Robert Louis Stevenson's *Treasure Island* and the source of Jim Hawkins' surname. Then, Daniel Defoe is supposed to have met Alexander Selkirk here. Defoe's story of Robinson Crusoe is based on sailor Selkirk's experiences when left on an uninhabited South American island for four years after quarrelling with the captain of his ship. Rescued by Woodes Rogers, a Bristol privateer, he was brought back to England at the end of the voyage. Although Woodes Rogers lived in Queen Square close by and may well have been a visitor to the inn and Selkirk did come to Bristol, there's no evidence that either of the authors Defoe or Stevenson ever set foot in the Llandoger.

In September 1869 the owner of the inn was J. F. Dalton, a married man with eight children. He was also agent to Mr Payne, a shipbuilder and steam

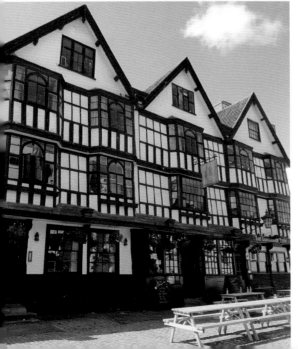

The seventeenth-century Llandoger Trow. The timbered houses that make up the inn are considered to be the finest Bristol survivors of their period.

tug owner. Dalton had promised a guest at the Llandoger that he would send a tug to Gloucester to bring down one of the man's vessels. There was a gale blowing with terrible force from the west and Dalton couldn't get a captain to do the job, but determined to keep his word, he decided to take control of the *Forager* tug himself, with a three-man crew. But the little steam tug could not cope and was overpowered by the ferocity of the storm. Dalton was a strong swimmer and jumped in to try and reach land. He drowned, although ironically, the men who stayed aboard got driven ashore at Hallen and were saved. His body was recovered at Oldbury Pill and was identified by a telegram in his pocket.

16. The Glass Cone

This truncated cone is a reminder of the Bristol glass industry that flourished and peaked in the eighteenth century. It was a time when prosperity was shining on the area. New houses being built needed copious amounts of window glass, fine glassware for the dining room was the trend and on top of that the American colonies provided a ready export market.

There were fifteen glasshouses in 1722, which were marked on maps, and the smoke from their cones made them real landmarks. Several of these glasshouses were in the Redcliffe and Temple area, the Redcliffe caves being dug out as the sandstone was extracted for glass manufacture. Local coalfields supplied the fuel for the furnaces.

In fact the glass industry came to Bristol because of the coal. In the seventeenth century a law had been passed making it illegal to use wood in commercial furnaces as timber was needed for Royal Navy ship-building. So glass-makers moved from forested areas to those where coal was plentiful.

Each cone was eighty to 100 foot high with archways all around the interior of the base and had a large central furnace. Once that was fired up, the upper brickwork would get tremendously hot. The huge updraft formed through the

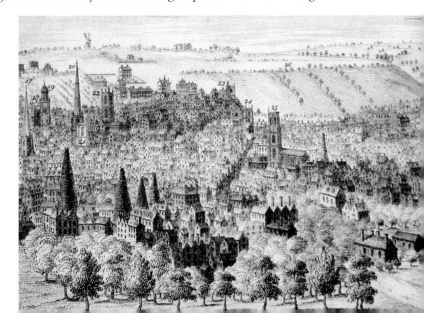

Eighteenth-century print of a view of Bristol showing the glass cones (Bristol Reference Library).

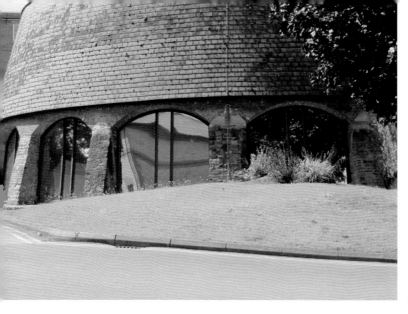

The base of the Redcliffe glass cone.

cone enabled it to reach the required temperature of around 1,300 degrees to fuse the sand, lime and soda or potash together.

The glass-maker would gather a molten mass of glass from the furnace on to a hollow tube called a blowing iron and by blowing evenly, swinging and shaping with tools, could make what was required. Drinking glasses could be plain or with delicate twisted stems and it also became popular to colour them with cobalt oxide to achieve the famous Bristol Blue Glass. Window glass of this time, called Crown Glass, was also blown and was restricted to small panes which were cut from the outer part of the disc shape.

Most of the glasshouses were relatively short-lived and several owners became bankrupt, especially when the Americans started up their own works and exports reduced drastically. There was only one glass manufacturer left by the mid-nineteenth century, though it was quite a large operation, producing many bottles. This cone in Prewett Street was only used for glass for about forty-five years until 1812. It was later used by Messrs Proctor & Sons for artificial fertiliser manufacture. It is now incorporated into the restaurant of a hotel.

17. The New Room

'Our New Room in the Horsefair' is what John Wesley called it. It was built in 1739 as a meeting and preaching place and was enlarged nine years later when a stable was also added. It was a very sober chapel, for Wesley had no truck with ostentation and self-importance. Benches were set round the outside of the room with the high two-decker pulpit at the end in front of a window and many would have stood in the central portion, illuminated by a skylight. Even so, Wesley faced criticism from George Whitefield, his fellow evangelical, that the Room was 'adorned', to which he replied that there were but a green cloth nailed to the desk and two candle sconces.

The New Room with the stable at the right, seen from the courtyard in Broadmead.

While many Church of England clergymen held social standing to be of great importance and tended to consider labourers as ignorant and unworthy, Wesley was concerned with the welfare of the poor, both physically and spiritually. It was a time of meagre harvests and severe weather causing spiralling food prices, which led to hunger, ill-health and the spread of diseases. He opened dispensaries to provide medical treatment for sicknesses, based on natural remedies.

Wesley felt it was of the greatest importance to take the gospel to the people and gave his first open-air sermon near Avon Street, Bristol on 2 April 1739. Between then and 1790 he travelled about 250,000 miles round the countryside on horseback, preaching especially to the poor and downtrodden. In 1759, he visited the French prisoners of war held at Knowle to the south of Bristol and was horrified at the dirty conditions and their ragged clothing. When he preached that evening the collection was put towards shirts, waistcoats, breeches and stockings and the news having spread, mattresses and blankets were provided by the corporation.

The New Room also became the headquarters for Wesley and the Methodist preachers serving the west of England and Wales. The rooms upstairs, where they could rest and study, are still in place today and you can see Wesley's preaching gown and desk. John and his brother Charles, writer of many well-known hymns, had a profound impact on religious and social aspects of the eighteenth century.

The first Methodist conference was held in the New Room in June 1744 and many more in the following years. After Wesley's death however, Methodists gradually started to attend other chapels in Bristol instead and the building was later taken over by the Welsh Calvinists who installed pews. In the late 1920s it was purchased by Mr Edmund S. Lamplough, and after restoration work was

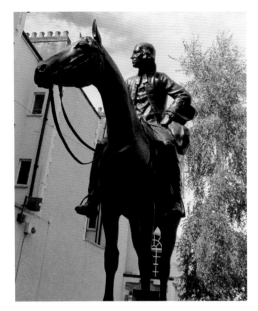

Statue of John Wesley on horseback by
A. G. Walker, 1932, in the courtyard of the
New Room.

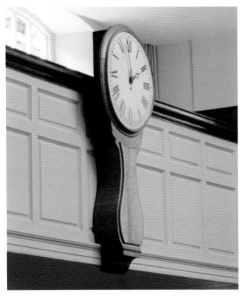

John Wesley's wall clock on the gallery in
the New Room. A very restrained design
to suit the surroundings.

carried out under the direction of Sir George Oatley, was reopened for Methodist
meetings on 13 February 1930.

18. The Exchange

In the Middle Ages the merchants would meet to carry on business in the Tolzey,
an arcade which was alongside All Saints Church, open to wind and weather.

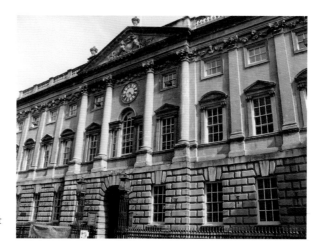

The eleven-bay façade of the Exchange, often considered to be architect John Wood's finest design for a civic building.

There were four brass pillars, known as the Nails, for 'men to lean on, pay and tell money'. By 1720 the gentlemen were not only complaining about getting wet, cold and windblown but also being 'always annoyed and disturbed by horses, drays and carriages continually passing that way'. They wanted somewhere more comfortable and were willing to pay out for the convenience of an Exchange, similar to the one in London. The plan was for a building with the appearance of one grand structure, which would allow 600 people to assemble in it.

In 1740 the Guilders Inn and Tavern in High Street, the Rummer Tavern in All Saints Lane and the Tuns Tavern in Corn Street had been purchased, along with several other old houses and the ground cleared. The Tuns had been owned less than a century before by Ralph Oliffe, a man described by the Baptists as 'a notorious drunkard', elected mayor in 1665, a time of religious intolerance, bent on persecuting the Non-conformists by sending out organised groups from his back parlour to 'pounce upon their humble victims who met for worship elsewhere than the parish church'.

The architect of the Exchange was James Wood the Elder and he designed an impressive building with a frontage featuring pilasters and pediments and a frieze of swags. Inside, as contrast to the rather stiff coldness of the vestibule, the grand hall was decorated with riots of ornate plasterwork. It must have seemed more palace than place of business.

On opening day, 21 September 1743, the streets having been 'Swept and Clear'd of every annoyance', at 11 a.m. a procession began. First came the masters and boys of Queen Elizabeth's Hospital and the Grammar School, then the Exchange Keeper and next the members of the trade guilds. The civic dignitaries made up the last part of the walking procession and finally came forty-eight coaches and carriages. The whole procession extended about three quarters of a mile through the streets, which were lined with cheering people, while church bells rang and cannons on Brandon Hill fired.

The Nails were set in front of this grand new building. They are all different, being made at various times in the late sixteenth and early seventeenth centuries.

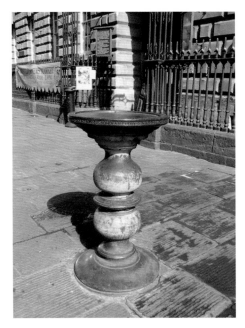

One of the bronze Nails in front of the Exchange. All slightly different, they were separately made over approximately forty years from 1595.

One bears the name of John Barker, mayor during the reign of Charles I, who represented Bristol in the 1623 parliament. The clock of 1822 is interesting as it has two minute hands to show both London time and Bristol time, before the approximately eleven-minute difference was wiped out by the countrywide adoption of Greenwich mean time, due to railway travel.

Market traders originally set up their stalls in the High Street and Broad Street. However, according to the eighteenth-century historian Barrett, these stalls became the cause of 'great obstruction of passengers and general inconvenience of the inhabitants'. When planning the Exchange some of the cleared ground was allotted to the construction of St Nicholas Market as a way of solving the problem. Barrett concludes, 'the city was made also thereby much more airy, pleasant and healthful.' Nowadays, stalls are again regularly set up in the streets close to the permanent St Nicholas Market, but modern inhabitants seem to consider them more of a pleasure than an inconvenience.

19. The Colonnade, Hotwells

The waters of the Hotwell Spring were described by William Wycestre in the fifteenth century as being warm as milk. The water rises from the river bank at the foot of St Vincent's Rock at 76 degrees Fahrenheit at the rate of around sixty gallons per minute. The water contains a large amount of mineral elements, claimed as curatives for skin diseases, scurvy, diabetes, gout and rheumatism.

It promised to be a great money spinner as the interest in spas increased but the problem was enticing people into the rocky reaches of the Gorge. There were

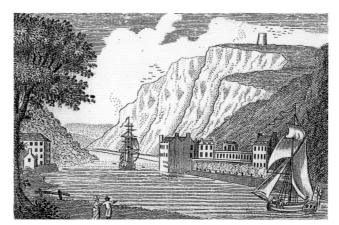

An old print showing the Hotwell House and the Colonnade on the banks of the Avon (Bristol Reference Library).

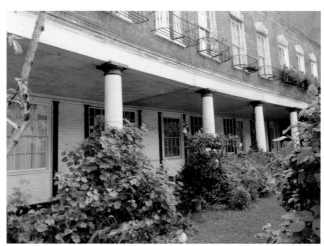

The Colonnade today, showing the covered walkway in front of what were originally shops to entice visitors to the Hotwell.

always Bristolians ready to speculate on the prospect of raking in the cash however and at the very end of the seventeenth century, a group of the most prominent leased the well and set about enclosing it, building a Pump Room and laying out paths for the 'great influx of nobility and gentry from all places' as Matthews' *Bristol Guide* later put it.

During the eighteenth century it was very popular, the season being April to September. Alexander Pope came and lyrically described the view from the back of the Pump Room as looking on to a vast rock 100 feet high of red, white, blue, green and yellowish marble, all blotched and variegated and, if that wasn't enough, in another direction, at vast depths below flowed the river, winding in and out of rocks of a hundred colours. He wasn't so impressed by the Hotwell waters though, saying they were of no great strength and took longer to work than the warmer ones of Bath, plus the transport facilities certainly weren't good enough.

There were various places of entertainment to encourage visitors to enjoy themselves and spend their money, including concerts, plays, fine suppers and riding excursions on the Downs. In 1786 Samuel Powell came up with the idea

of actually putting shops on the site. He leased the land below Rownham Wood, next to Rock House and built the Colonnade. This was a curved block of six shops with a colonnaded walk in front and living accommodation over it all, on the second storey.

Ann Yearsley operated a circulating library here. Described as a rustic poetess, an unusual mix of lack of education and natural ability with poetry, she had been befriended by Hannah More, the local writer, social reformer and philanthropist. The two women later quarrelled and Ann took her money she had been paid by a bookseller for her work and set up her library. She obviously quarrelled with others as well, as it was commented 'would that her command of temper had been equal to her genius'.

But the great popularity of the Hotwell did not last beyond the dawn of the nineteenth century. Increased rents and charges put up prices and visitors went elsewhere. There were other spas in England offering superior facilities and with the end of the Napoleonic Wars, those of Europe increasingly beckoned. The old Hotwell House was pulled down in 1822 and although a new one was built, it never regained the success of the past. Samuel Powell died, aged eighty-three in December 1830, but the Colonnade building still remains, as a reminder of 'the light of other days at Hotwells', albeit alongside a very noisy main road.

20. Theatre Royal

From 1737, opening a theatre in England was not just a case of getting together subscribers to pledge money, erecting a suitable building and employing actors. The government, lampooned from the stage by satirist playwrights, had passed a Licensing Act, which meant that a theatre could not perform drama without a licence from the Lord Chamberlain, who was also responsible for censorship of material. The theatre in King Street may have been built in 1766, albeit discreetly

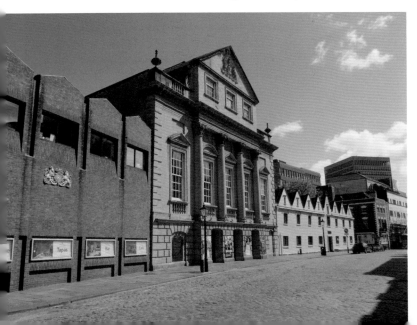

Theatre Royal in King Street, home of Bristol Old Vic. The columned façade of the Coopers' Hall is to the right of modern building.

behind two houses which formed the frontage and served as the manager's accommodation, but the all-important licence was not in place.

So they called their opening performance, *A Concert of Musick and Specimen of Rhetorick*. William Powell, a well-known actor from Drury Lane, was a partner in the venture and took part on the first night in *The Conscious Lovers* and also read a florid prologue written by David Garrick. The King Street theatre attracted many other London actors but although Powell made appearances over two seasons, he suffered from ill-health and died in July 1769, being buried in Bristol Cathedral.

It wasn't until nine years after Powell's death that the Royal Licence was finally granted to George Daubeny of Bristol Esq., for the term of twenty-one years, commencing 10 April 1778, 'to establish a Theatre or Playhouse in the City of Bristol and to keep a Company of Comedians to Act such Tragedies, Plays, Operas and other Entertainments as are licensed by the Chamberlain'. A wide variety of acrobatic and musical acts as well as actors like Edmund Kean and Sarah Siddons appeared on the King Street stage.

In 1819 William McCready had taken over the lease of the Theatre Royal at a rent of £300. During his ten-year tenure gas lighting was fitted. His widow Sarah McCready followed him as owner/manager. In 1842, you could have seen plays like *Macbeth* and *The Rivals* but also *Jane of the Hatchet* starring Maria Tyrer, promising the sudden appearance of sixty female warriors, culminating in the triumph of Jane and her Amazons. There were winter concerts when the pit was covered and the interior brightly lit every evening except Saturday. There were pantomimes such as *Puss in Boots* but also with less familiar titles, like *Peeping Tom of Coventry*.

James Henry Chute became owner/manager in 1853 and by now the theatre was looking a little tired so it was treated to refurbishment and redecoration. Chute's sons carried on until the last decades of the century and such stars as Ellen Terry appeared. By the 1920s, it was in private ownership and the *Bristol Guide Book* describes it as being 'given largely to melodrama'.

There were fears that it would be closed as the owners put the building up for sale in 1942, after some war damage, but a new trust was formed and after the war it became home to the Bristol Old Vic theatre company, an offshoot of the London Old Vic. Actors like Peter O'Toole took part in the productions and it became immensely popular once more, though the renovations were less well received with complaints in 1955 that the new pink seats and carpeting made it look as though a modern cinema had been put into an historic theatre.

The 1970s saw the incorporation of the elegant Coopers' Hall façade into the Theatre Royal and twenty-first-century redevelopments have given it flexibility for the future.

21. The Chatterton House

Thomas Chatterton, Bristol's boy poet, had a short life which might have been different had his father not died in 1752, several weeks before Thomas was born.

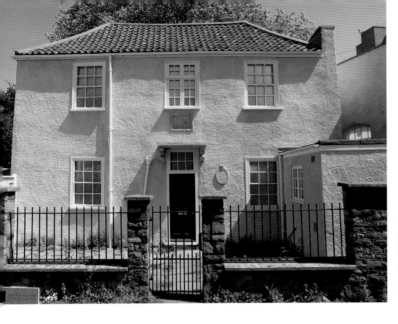

Thomas Chatterton's birthplace in Redcliffe Way, built in 1749 for the use of the schoolmaster of Pile Street School by Giles Malpas.

His father had already been master of Pile Street School for a few years when he married and shortly afterwards moved into the newly built school house, where daughter Mary was born. When her husband died, the widowed, pregnant Mrs Sarah Chatterton probably expected to have to vacate the snug house but it was fortunate that the new schoolmaster said he had no need of it and so she and her children, Mary and baby Thomas, were allowed to stay there for a while.

Young Thomas seemed not at all interested in learning. The Pile Street schoolmaster lost patience and declared him a total dullard. Thomas stayed at home with his mother who taught sewing and embroidery and he noticed her using old manuscripts as paper patterns in her work. These had been brought home by her husband from St Mary Redcliffe when an ancient chest had been cleared out, and anything other than deeds or legal documents had been left piled in the room, unwanted. Schoolmaster Chatteron had seen this as a ready source of useful scrap paper and put a basket full in his house.

Bright colourful illuminated letters on the manuscripts caught Thomas' imagination and he learned to read. He subsequently attended Colston's School, later being apprenticed to an attorney where he found the work boring. He was much more fascinated by the study of archaic words, compiling a glossary which he put to use in a series of poems written on pieces of the old parchment.

He spent hours in St Mary Redcliffe, although once in a letter he stated he was not a Christian, and presented his work as being found among the ancient church papers. The amateur antiquarians of the day were delighted by what they thought was genuinely from the pen of a mediaeval writer. But the author Horace Walpole was suspicious and discredited the young man.

Chatterton started to write accomplished political letters and satires, under pseudonyms, for periodicals. This proved a successful move and, as he once said, had the advantage of giving constant payment. He left his Bristol employment and went to London by coach, a snowy April journey. Encouragingly, some of his political work was published there in magazines, though the daily papers, he

Frontage of Pile Street School preserved after the rest of the building was demolished.

claimed, were reluctant due to patriotism. Unfortunately an important patron died and then things did not go so well. In August 1770, at the age of seventeen, he was found dead in his Holborn lodgings from self-administered arsenic, which may have been an accidental overdose rather than actual suicide, as arsenic was used as a medication.

The Pile Street School was pulled down due to road alterations and the façade of the school remains, attached to the house.

22. Bath Street Brewery

Beer was produced near Bristol Bridge for almost three centuries. Philip George took over the fifty-year-old Ricketts' Porter Brewery in 1787. The son of a distiller and a member of the family firm, he also dealt in malt and hops and became involved in lead shot manufacture. William Watts of Bristol had taken out a patent for lead shot and Philip George became a partner in his company, later buying out Watts.

The brewery faltered a little at first, but Philip George took advantage of local shipping routes to start up a trade with Ireland in porter, a dark well-hopped beer, which became gratifyingly profitable. Liverpool was another market which was appreciative of George's Bristol porter.

But a very important boost came just a couple of years after Philip's death with the 1830 Beerhouse Act. This enabled anyone to brew and sell beer on payment for a licence and led to the opening of hundreds of new public houses. There had been concern about the widespread ravages caused by alcoholic beverages like gin, and beer was seen as far preferable. Although some beerhouse owners chose to brew their own beer, to many running a house was a source of secondary income to their proper job and it was easier to buy in from what was known as a common brewer, such as George's. Trade boomed.

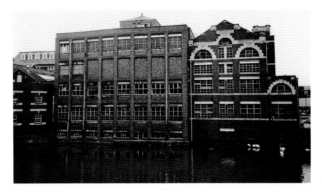

The brewery buildings before
the 1999 closure.

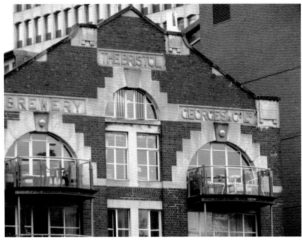

The Keg Store (seen at
right on photo above)
with Georges name carved
on it, now converted into
apartments.

Brewing on a large scale was not without its problems. The premises contained
several large stone slab-based fermenting squares, each holding the equivalent of
200 barrels of beer. In 1871 one of these squares burst, sending massive pieces of
masonry flying into the air, allowing carbonic gas to escape and the beer to flood
out. Two men were injured, one being hit on the head by a stone slab and carried
some distance on the liquid, from which he was quickly rescued, while the other
was washed away by the flood and wedged between the floor and a structure a
few inches above it. No one realised he was there until they heard him groaning
and it took two men to extricate him.

By the late 1860s government thinking was that there were now far too many
beerhouses and licences would have to be limited. The Wine and Beerhouse Act
of 1869 brought licensing under the control of magistrates, setting out strict
rules. George's started to buy up pubs to keep their stake in the market, putting
in landlords who were tied to purchasing the company's beer and by the early
twentieth century George's owned about 1,000 pubs in the West Country.

The brewery site expanded to about three acres of river frontage from Bristol
Bridge to St Philip's Bridge. The delivery drays drawn by grey horses were a
familiar sight, although for out-of-town deliveries these were superseded by

lorries, originally steam-powered and later petrol-driven. Several other smaller breweries were taken over but in 1961 George's were bought out by Courage, who then used the premises. The brewery closed its doors in 1999. It has now been converted into apartments.

23. Portland Square

The parish of St James became very densely populated and in 1787 the inhabitants of St James' Square put forward an argument that they wished the parish to be divided. There were some upmarket houses but also a lot that were not so salubrious, so possibly this was an attempt by the upper-class occupants to distance themselves from the impoverished. After initial quibbling, the division of the parish and the building of a new church was approved and legal formalities were carried out.

Less than half a mile from St James was an area of ground called Barr's Leaze. It was right on the city boundary, mostly owned by the Diocese and used for growing fruit and vegetables by labourers who had no official right to be there. They were sent packing, the land was readied for building a square of fine houses and the foundation stone was laid for the church in 1789.

The houses in Portland Square exhibit no marvellous architecture. They are just large, solid Georgian houses. Who the architect was is a matter of dispute. Some say it was William Paty, others, the mason Daniel Hague, but the drawings bear no name.

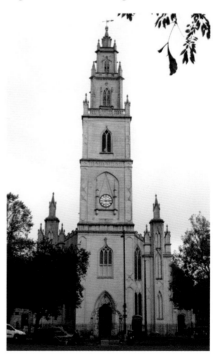

St Paul's church in Portland Square, from the central gardens.

When it came to the church, the corporation engaged an architect to produce a design, but it was declared to be too expensive. Did Daniel Hague come up with the alternative or was it strongly influenced by the ideas of the vicar of St James?

St Paul's has long been known as the wedding cake church because of the tower's tiered shape. It has nothing of the grandiose or elaborate about it, though it does exhibit a sense of quirkiness. A guide book from the beginning of the twentieth century labelled it nondescript but something with all columns or curlicues would have dominated rather than blended with the square.

The square's central garden with its shrubs and trees softened the expanse of stone and probably added a bit of order to the traffic which passed through. There was a statue in honour of George III's fifty-year reign but some anti-royalist vandals decided to topple it in 1813, breaking it into several pieces and making repair impossible. It was never replaced.

It was unfortunate for Portland Square that, after the end of the Napoleonic Wars, Clifton began to emerge as the place to be for families who could afford to live in large houses. It was further away from the hustle and bustle of the town, well above the smells that came from the harbour and near the green expanse of the Downs.

In 1831 a sales notice for one of the houses described it as having been used as a lodging for boarders for many years. It offered a servants' hall, kitchen, arched cellars, three parlours on the ground floor, two drawing rooms and two bedrooms on the first floor, with seven bedrooms on the upper storeys. Although quite a few families still occupied the houses, in the 1860s tea dealers took over one building, to be followed by corset makers when the tea firm relocated a few doors away. Boot and shoe makers came to dominate, starting in one house and taking over adjoining ones as they became vacant. By the end of the nineteenth century at least one of these had mushroomed into a full-scale factory.

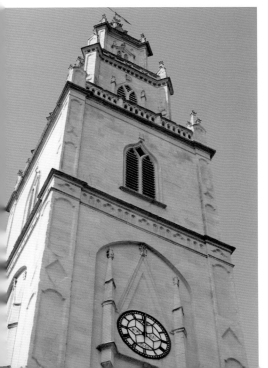

A close-up view of the distinctive tower, after restoration.

Once this industrial system moved in, each building became ripe for similar development and furniture makers and paper manufacturers and their machinery took up residence. The Salvation Army and the YWCA made use of other houses for hostels. The Second World War brought bomb damage and with shabby frontages plastered with signs, mid-twentieth-century Portland Square looked like a lost cause. The church closed finally in 1988 and various schemes for it fell through.

Made a conservation area in 1975, office use increasingly replaced the manufacturing. Gradually, other buildings were divided into apartments. Eventually, at the beginning of the twenty-first century, the church was renovated by the Churches Conservation Trust and converted for use by Circomedia. Now the square is coming back to life as more people call it their home rather than their workplace.

24. No. 7 Great George Street

In 1764 John Pretor Pinney had gone to Nevis in the West Indies where he had inherited his cousin's run-down plantation, Mountravers. He then bought a number of slaves and turned the plantation into a successful operation. When he returned to England twenty or so years later, it was as an extremely wealthy man. He was one of a group of Bristol merchants with plantation holdings in the Caribbean.

He could well afford the elegant detached six-storey house he bought at No. 7 Great George Street, off the steep, recently built Park Street. He paid great attention to its decoration and furnishings, which were restrained rather than flamboyant. There was a view down the hill to the Cathedral and a glimpse of the

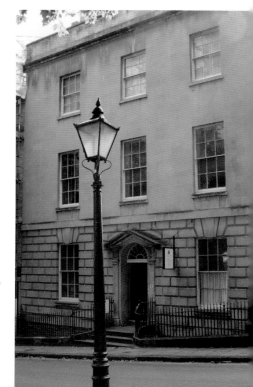

No. 7 Great George Street, the Georgian House Museum. At the back of the house the ground falls away, so the basement kitchen has plenty of light.

harbour. Downstairs he had a plunge pool installed and the kitchen would have been filled with light from large windows but also heat from the huge fireplace. Up the stone staircase, the Pinney family entertained guests such as Lady Nelson and the poets Samuel Taylor Coleridge and William and Dorothy Wordsworth.

Coleridge gave a series of lectures against slavery but though Pinney had expressed some concerns about the practice in earlier years, he had decided it was acceptable and necessary. He had brought a personal slave servant called Pero back to Bristol with him. Pero had been bought as a boy, along with his sisters, not long after Pinney's arrival in Nevis. After returning from the second of his two visits back to Nevis, Pero started to drink heavily and his behaviour changed. He fell ill and died in 1798.

Pinney however had freed Fanny Coker, his wife Jane's slave maid, in 1778. She also had come to Bristol, remaining in their service and becoming a member of Broadmead Baptist Church. She did make a return journey to Nevis, although not willingly. She later accompanied Jane Pinney on visits to London and other towns around England. Fanny was left an annuity in John Pinney's will, although she died a couple of years later, buried in the Baptist burial ground, leaving money and possessions in a will of her own.

John Pinney had sold his plantation of Mountravers in 1808, after the slave trade was made illegal. His eldest son was not a good businessman and his second son died young, so he gave No. 7 Great George Street to his third son Charles, who took over his business. Charles sold the house in 1861 and it was given to the city by Canon R. Thorold Cole in 1937. The building became part of the museum, known as the Georgian House.

25. The Seven Stars

The Seven Stars in Thomas Lane, important for its part in the abolition of the slave trade.

In the summer of 1787 a young clergyman named Thomas Clarkson came to Bristol. He was on a mission to find evidence about the slave trade for an abolitionist committee and was travelling round England visiting various ports. He was determined that no dangers he might encounter would keep him from exposing the truth.

For years Bristol ships had been plying their triangular trade down to Africa, across to America and back home. The American plantations were in the market for African slaves and the merchants who invested in the ships wanted profits. To most of them slaves were just another commodity like the barrels of molasses and rum they bought with the money received for their human cargo and they packed them together almost as tightly. In one small ship thirty slaves were to be kept below decks in a space twenty-four feet long, between four and eight feet wide and less than three foot high.

Clarkson discovered that not everyone in Bristol was happy about this trade being carried on. He met surgeons who had worked on slave ships and were horrified by the conditions. He also met Mr William Thompson, the landlord of the Seven Stars, by St Thomas Church, an inn which was used by sailors as lodging while on shore.

Thompson had heard more than his share of stories of how both slaves and crew were treated in the ships. He was happy to help Clarkson and also accompanied him to many other inns in the harbour area, where sailors told their own tales of nightmare voyages. For these sailors it was sometimes a case of being desperate for work and having to take what was on offer and sometimes being plied with drink and persuaded to sign on whilst under the influence.

According to another member of the Committee for the Abolition of the Slave Trade, Thomas Clarkson 'exerted himself beyond the strength of any ordinary mortal' and his association with Mr Thompson helped him avoid getting into trouble. Certainly the evidence gathered through this grass roots assistance was invaluable.

Many non-conformist church leaders backed the anti-slavery movement and public feeling that the trade should be ended spread. But even though the Abolition of the Slave Trade Act was finally passed by the British government in 1807, those who were already enslaved in British territory were not freed until the mid-1830s. Thomas Clarkson continued to campaign against slavery throughout the world for the rest of his life.

It may be tucked away down Thomas Lane and have even been described in the 1900s as a poor-looking inn, but the Seven Stars is a true survivor.

26. Windsor Terrace

Clifton – that was the place to build in the later eighteenth century. It was hot property and ripe for speculative development. But sadly a trap for the unwary, like William Watts, self-made man, a plumber who had discovered the way to make perfectly round lead shot for muskets, which gave vital accuracy. By

The terraces of Clifton high above Cumberland Basin.

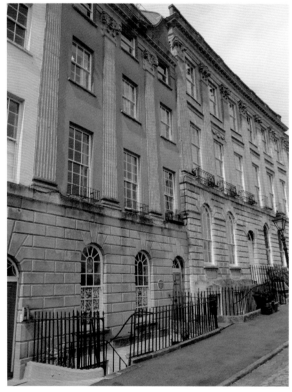

Windsor Terrace, Clifton, a cautionary tale in the speculative building of a terrace.

building a tower on his house in Redcliffe and dropping the molten lead through the air, from top floor to the bottom, it formed into perfect spheres and he thereby amassed a tidy fortune. He was ready to invest it in a project in Clifton.

The site for Windsor Terrace, planned as a large, elegant crescent high on the rocky slopes of the Gorge, was dramatic but precarious. What it required was a huge seventy-foot retaining wall to secure the foundations of the end house. Work on it began in 1782 and every day more of Watts' money drained away with seemingly little to show for it. Despite subletting plots to others, he became bankrupt and therefore not only lost all connection with what was mockingly

dubbed 'Watts' Folly', but all his worldly goods as well. Two central houses were completed but then, due to the economic bust of the mid-1790s, building stopped. Construction waited for years to get going again. The new houses were smaller in height, but pilasters cut to suit the original plans were apparently still available, so they were used. Other details were carried out in a seemingly incompetent architectural manner.

So completed, though a little less than harmonious in style, the terrace at last became home to those wishing to enjoy the healthy air and beautiful views down the slopes and across to Dundry. To No. 4 came Hannah More in 1828. She was near the end of a life which had been remarkable. As a young woman with a great interest in literature and theatre, she had written plays which were actually staged and was friends with David Garrick and his wife as well as Dr Johnson and Joshua Reynolds.

In her thirties her interests turned more to religious, social and educational aspects and she produced tracts, essays and poems in great numbers. She was an ardent member of the anti-slavery movement, as well as promoting changes in women's education. She actually made money with her writing and in contrast to poor William Watts, left a sizeable amount when she died. A legacy of £10,000, which was the same amount as Watts had made from his lead shot patent, a great sum in those days, was bequeathed by Hannah More to charities, schools, hospitals and religious societies.

27. Royal York Crescent

1793 was a bad year for Bristol builders. At least twenty went bankrupt in the first six months and more followed. Of course it wasn't just the builders and developers. The newspapers were full of bankruptcy notices for people of every trade and occupation all over the country. There had been the uneasy period of the French Revolution, now France declared war on Britain, trade stalled, banks had over-extended credit and crashed, workers were laid off, prospective speculative

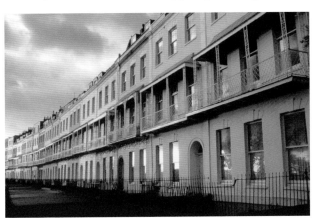

Royal York Crescent at twilight.

backers hung on to the money they still had and people were nervously reluctant to pay out for new houses.

Royal York Crescent, conceived as a dramatic curved sweep across the Clifton hillside had been started in 1791. The builder, John Lockier, who had started off as a furniture maker and wood importer, was one of those who went bankrupt in the spring of 1793. The shells of the unfinished houses stood as a symbol of unrealised hopes and broken dreams.

The War Department had a more prosaic attitude. They bought the land up intending to house soldiers, so ending the practice of billeting soldiers in taverns and inns, which was highly unpopular with the landlords. But though the inhabitants of Clifton might welcome a sprinkling of genteel red-coated officers, an en masse invasion was regarded with horror.

A petition against this idea being successful, the land was then sold back to the market to complete the building of the terrace of forty-six houses. Nos 1–3 were run as a school, which was attended by Eugenie de Montijo, who became Empress of France. Many years later No. 2 was in the occupation of Charles Tovey, wine merchant.

In 1880 a newspaper sale notice for some houses in Royal York Crescent stated they had front garden land on the other side of the road, and Mr Tovey pointed out that this land was actually held in common even though at least one of the house owners had turned the piece opposite their house into an untidy kitchen garden complete with a glass cold frame. Years before he had unsuccessfully tried to get the residents organised to lay out and plant the area as a 'pleasure ground' for their joint use. Now, he suggested, was the time to actually get this done. The garden was set up accordingly and although it went through a rough patch in

Vaulted basements from the roadway and a raised pavement at entry level.

the mid-twentieth century, was revitalised and the area is used how Mr Tovey envisaged it.

Royal York Crescent was described in a 1900 guidebook as being prized for its magnificent view of the tall masts of the ships in the harbour. The tall masts may have gone, but now the Crescent is regarded as a magnificent view in itself.

28. The Louisiana, Bathurst Terrace

Bristol has one of the highest rise and fall of tides in the world which meant that vessels could be left stuck low in the mud at low tide. This not only seriously impeded the movement of ships for large parts of the day but it could cause damage to the vessels themselves as they tipped over.

The idea of a floating harbour, in which water could be kept at a constant level, was first suggested in the mid-eighteenth century and building a dam was the thought everyone came up with. That was fine, but where to build it, how the ships would get past this dam and what were the dangers from flooding, were trickier issues and this was where the engineers came in.

Firstly was John Smeaton's plan for a dam across the Frome where it joined the Avon and an entrance basin and locks at Canon's Marsh. Unfortunately that didn't go far enough. William Champion suggested the dam should be near Rownham but didn't seem adequately convincing about how this would cope with high tides and floods.

Twenty years passed and then, as pressure built to get something done, Joseph Nickalls and William Jessop were consulted. Nickalls wanted to put the dam at Black Rock in the Avon Gorge, Jessop at Vauxhall Point, with a large entrance basin nearby and then Smeaton made another submission. It was decided to put it out to competition so that different schemes could be considered and costed.

One of William Jessop's schemes was eventually approved and in 1803 work began on excavating a trench that became known as the New Cut, which would replace the previous course of the Avon. Hundreds of workmen were employed

The early nineteenth-century building, once the Bathurst Hotel.

to move the earth and then the river was dammed in two places – at Cumberland Basin and near Temple Meads with two locks 150 foot long and thirty-eight foot wide. This created a floating harbour of about seven acres, a section of river that allowed ships to permanently float without risk of grounding on the muddy bottom. The remainder of the river then flowed into the New Cut.

The newspaper trumpeted of 'the benefit and convenience resulting to vessels lying in the Floating Harbour, both in preserving their bottoms and expediting their sailing, are incalculable'. Soon houses for sale or rent were advertised as having the advantage of being within a short distance of or with a good view of the floating harbour and in contiguity of the New Cut.

One of the first buildings was the Bathurst Hotel, to provide accommodation for travellers in this new location. It has changed its name several times since, but still sports the distinctive black-painted ironwork of New Orleans-style balconies, and is presently called The Louisiana.

29. Temple Meads Station

Despite the triumphant construction of the floating harbour, by the 1830s the trade of the port had gone into the doldrums. The coming of the railway would be 'a great and important occasion to rescue the city from decay', declared Alderman Daniel of Bristol Corporation. Temple Meads was chosen as the terminus, although some people weren't happy about the number of acres being given over to it.

At the age of twenty-seven, Isambard Kingdom Brunel was appointed Chief Engineer of the Great Western Railway, from London to Bristol, and he designed the imposing station building with its great single-span-roof passenger hall behind a mock Tudor stone façade, all built in record time over two years. Carved proudly on the front are the words 'Great Western Railway Company Created by Act of Parliament MDCCCXXXV'.

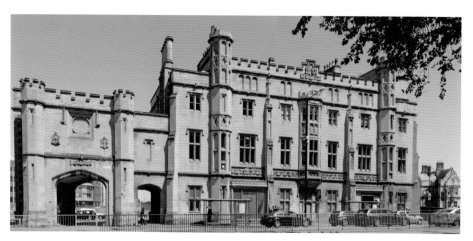

Temple Meads Old Station.

On 31 August 1840, the opening of the new station was quite an event. Not only did nearly 6,000 passengers travel on the trains but spectators crowded to watch from every vantage point they could, with bands of itinerant musicians and people selling cakes, apples and sweetmeats, eager to cash in on a market opportunity. The front of the station was decked out with flags and even nearby houses had banners hanging from them.

The first train consisted of three first-class and three second-class carriages pulled by an engine named Fireball, travelling to Bath and back, with an intermediate stop at Keynsham. Altogether ten trips were made to Bath and back, using four engines in total. The entire length of the railway from Bristol to Paddington was opened just under a year later. You could now get to London in four hours instead of the sixteen in a bumpy mail coach.

After came the Bristol & Exeter Railway which then built a wooden station to the right, though its offices were rather more palatial. The Midland Railway from Gloucester was also using Temple Meads and it was decided that a new joint station for all the companies was necessary, but it was not until the 1870s that extra platforms, refreshment stalls, dining rooms and a new entrance with a tower façade were added.

It wasn't just the transport of people of course. There were large goods yards, because heavy and bulky items, for the requirements of the city, could be carried easily by train. Sometimes this was to the further detriment of the trade of the port, as in the case of flour which used to come by boat from mills at Cardiff. Taking into consideration the dues that had to be paid to use the docks, it was cheaper to send it by rail.

The 1870s station tower and entrance up the incline. The tower originally had a French pavilion-style roof which was destroyed in the Blitz.

30. Great Western Dockyard and Brunel's Drawing Office

Although Isambard Kingdom Brunel was not born in Bristol, much of his work was carried out here. The son of Marc Brunel, a noted engineer, he first came to Bristol in 1828, convalescing after an accident in tunnel construction under the Thames, when he had dived to rescue some of those trapped. He entered and won the competition for designing a bridge to span the Avon Gorge, though unfortunately the lack of ready money meant that the Clifton Suspension Bridge was not completed until after his death.

Brunel had much more success in his lifetime, though also much stress, with other projects in Bristol. These included the Great Western Railway and the construction of two steamships for ocean travel, the SS *Great Western* and the SS *Great Britain*.

The SS *Great Western* was a wooden paddle steamer, built in William Patterson's yard and launched in 1837, but Brunel's vision of a larger, iron-hulled vessel meant that he needed a different kind of place to build it. Due to her size, the *Great Britain* would not even be launched in the usual way down a slipway, but floated out. To carry out the project, the Great Western Steamship Co. first excavated a dock on the south side of the harbour. Engine works and a drawing office were added to the complex where Brunel's original plans changed radically, even while the ship was being built.

When the time came to launch, in July 1843, the Great Western Dock was flooded and the *Great Britain* was towed out ready for engine fitting on the wharf. But fitting the engines and boilers caused a serious problem as the extra weight now made the *Great Britain* ride lower in the water and therefore too wide at that level to pass through the lock into the Cumberland Basin. The months dragged by but with the lock grudgingly amended and on a spring tide, the *Great Britain* was towed down the Avon in December 1844, never to return until brought back as a hulk in 1970 for loving restoration over the ensuing years.

The SS *Great Britain* in the Great Western Dockyard.

Part of the dockyard seen from the deck of the SS *Great Britain*.

Shipbuilding had been carried on in Bristol for hundreds of years and in fact the Great Western Dock was later used by other companies after the Great Western Steamship Co. folded in 1847 and in the twentieth century as a repair dry dock. Charles Hill's Albion shipyard produced the last commercial ship to be launched in Bristol, the *Miranda Guinness*, in 1976.

31. The Observatory

Clifton Observatory stands on the Downs, near the Suspension Bridge. Originally it was a snuff mill, built by James Waters, which was partially destroyed during a gale in 1777 and left derelict. It appears in that state in a few paintings by Bristol watercolour artists of the early nineteenth century.

In the 1820s, watercolour paintings of 'romantic' scenic subjects were becoming increasingly popular and the picturesque wooded area around the spectacular chasm of the Avon Gorge attracted local artists such as Francis Danby, Samuel Jackson and William West. In 1828 West rented the old snuff mill for use as his studio and proceeded to transform it into the Observatory, open to fee-paying visitors.

He installed two Newtonian telescopes – one of twenty-foot focal length, twelve-inch aperture and one of seven-foot focal length, seven-inch aperture, two Gregorian telescopes of eight-inch aperture, an achromatic telescope with eight-inch aperture, microscopes, an astronomical clock and transit instruments by Troughton of London. A couple of years later, at the top of the building, he placed a revolving dome with a very large camera obscura which became the major attraction.

A camera obscura projects a full-colour panoramic view of the surrounding area on to a white surface inside a darkened room. A box on top of the building contains a convex lens and sloping mirror. Light is reflected vertically downward

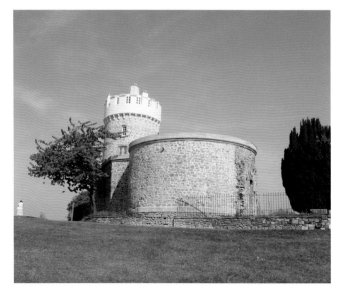

The Observatory on
Clifton Down.

The Clifton Observatory
above the Gorge with the
railed cave entrance in
the rock face beneath.

on to the table, giving a true and accurate moving image. The technique, which
originated in the sixteenth century, gives best results on bright days. A newspaper
advertisement of June 1830 described it as 'embracing the whole of the
surrounding scene from the gallery to the horizon'.

A few years later West had widened his interests to the daguerreotype, an early
kind of photography, where images were captured directly on a thin piece of
silver-plated copper. As this was a negative-less process each image was unique
and copies could not be made. In September 1839 he demonstrated this to the
Philosophical Society at the Bristol Institute before putting on exhibitions for
visitors to the Observatory.

William West not only lived in and extended the Observatory, but he dug a
2,000-foot tunnel to provide access to the cave (known variously as Ghyston's,

St Vincent's or merely Giant's Cave) visible in the face of the rock below. There must have been a way to it in the past as Roman pottery was found there, though any path has eroded over time.

Like the others in the Bristol group of artists, West travelled to British scenic areas like Devon and Wales, but also to Europe. Paintings of places in Switzerland and Norway display his talents in depicting rock and water. But his fascination with the grandeur of nature was equalled by his fascination with science and engineering and he made one trip to Fribourg to investigate the steel wire used on a suspension bridge there, to inform Brunel who was building his own bridge so near to West's Clifton Observatory.

32. Queen Square

Queen Square gives a sense of openness and light that was never present in the older part of the city. Although conforming to an overall plan, with brick frontages, the houses had no imposed design and were built over a number of years from the beginning of the eighteenth century, to different architectural specifications. These were houses meant for the wealthy merchants and those nearest the Quay had offices and warehouses attached.

Nowadays it seems unbelievable that in 1937 an arterial road was insensitively sliced diagonally through this square and that a hundred years before that it was the scene of mob violence backlit by flames.

The Bristol Riots of October 1831 initially stemmed from unrest and anger at the rejection of Parliamentary reform by the House of Lords, but had a lot to do

The mayhem in Queen Square as shown in a contemporary print (Bristol Reference Library).

with the dislike of a more or less self-elective city corporation and very much with the easily whipped-up fury of the mob when not controlled by adequate policing. At the opening of the Assizes by the anti-Reformist Sir Charles Wetherell there was political demonstration which flared into riot culminating in aggressive plunder.

The Mansion House in Queen Square was attacked and the doors forced, allowing the crowd to burst in and smash up anything they could get their hands on. A contingent of cavalry rode in amongst the rioters, but the officer was more intent on conciliation than subjugation. There were a few skirmishes and everyone hoped things would quieten down overnight but a lack of decisive decisions by the military or the corporation meant that worse was to come.

On Sunday the rioters reappeared and started by throwing stones. Soon private houses were ransacked and set afire. Some of the mob rushed away with their ill-gotten gains, others drank themselves stupid on looted wine, reeling around, climbing on to rooftops and the statue of William III and even perishing in the flames. The north and west side of the Square were one massive bonfire. It was not alone in suffering damage, as prisons and tollhouses were destroyed, but it presented a horrific picture of general devastation.

On Monday morning the cavalry was finally mobilised to charge and retribution was carried out, resulting in further maiming and killing. There were trials, hangings, transportations, recriminations and compensation payments.

Although the scars of October 1831 were obliterated and houses rebuilt, in the 1930s the construction of Redcliffe Way passing through meant the demolition of a building on each of two corners. In the later years of the twentieth century it was recognised that a great wrong had been done in carrying out these works. So in 2000 the arterial road across the square was removed and the diagonal walks replaced.

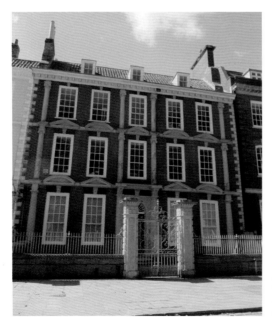

No. 29 Queen Square, built around 1710. It survived the conflagration of the Riots.

33. Hotwell Road

After the turbulence of the riots faded, there was another fear occupying the minds of many of Bristol's citizens. In 1831 there was a serious outbreak of cholera in European countries and it seemed inevitable that by the next year the disease would find its way into the port of Bristol. It came in July and according to a newspaper, James McDonald, a sailor, was the first recorded person to die, having been taken ill at a lodging house, No. 84 Hotwell Road.

In a fortnight the disease had claimed thirteen lives, although seven more had totally recovered. There was talk of cholera hospitals and wooden buildings for the reception of patients were erected in a yard in Redcliffe, a move strongly opposed by those living nearby, who protested against 'making it a pest house'. By August, in spite of precautions and preparations, the cholera epidemic was raging and nowhere more violently than in St Peter's Hospital, the workhouse. There were about 600 poor and sick crammed into the place, some of the children eight to a bed, and they succumbed in droves. Altogether it is reckoned there were 584 deaths before the disease burned itself out.

Bristol suffered from overcrowding, contaminated water supplies, inadequate sewage disposal, with ditches full of stagnant water, and open ash tips on the streets. It was calculated that the average age at death in the city was twenty-five years and half of new-born children died by the age of five. Those who died were generally buried inside the city in old and inadequate cemeteries.

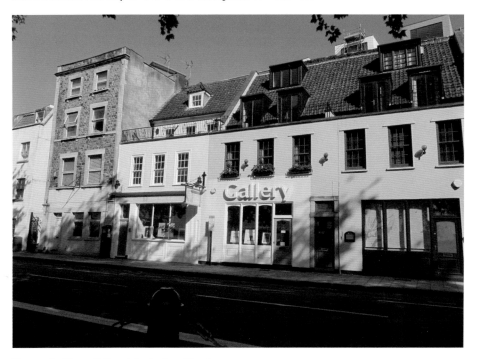

Houses in Hotwell Road, including No. 84.

It wasn't surprising that cholera struck again in a massive way in 1849. In June a hospital especially for those afflicted by the disease was set up in Peter Street. Altogether around 2,000 people died and it was noted that most of them were poor and vulnerable, who had lived in such bad conditions. The next year a detailed inquiry into the state of the city's sewerage, drainage and water supply was carried out. An article in a Bristol newspaper summed up with, 'The cholera has fully demonstrated that what Bristol suffers from is not its locality, the privations, the filth or the vice of its inhabitants, but from the want of permanent sanitary works'.

Bristol Local Board of Health was set up in 1851, tasked with improving the sewage disposal system, maintaining, lighting and cleansing the streets and preventing epidemic diseases. It was a wide brief and there were many hurdles to be overcome but they set about dividing the city into sections and installing trunk and branch sewers for each section.

Also the quality of water was dramatically improved. Bristol Waterworks had been formed just a couple of years before the epidemic and Dr William Budd, a founding director of the company, had done considerable research into the spread of disease through contaminated water. He knew that supplies drawn from the Mendips and piped into the city's houses would be fresh and clean rather than polluted. Public drinking fountains also began to be installed.

It all took time and there were other cholera and typhus outbreaks but in 1886 Bristol's retiring first Medical Officer of Health, a young doctor at the time of the severe epidemics, reported the city's much cleaner bill of health with not a single case of typhus the previous year and overall mortality rates much reduced.

The building now No. 84 Hotwell Road may well not have been No. 84 in 1832 as there have been changes in the numbering system, infills and removals over the years.

34. St James' Priory

In around 1127, Robert Earl of Gloucester had given land and stone to build a Benedictine Priory outside the city wall. His chosen site was on the other side of the Frome, in the area called the Barton. The west front with its circular window and zigzag moulding is where its Norman origins are clear to see.

The tall tower came much later, in 1374. Local people who now lived between the city wall and the priory grounds, petitioned that they be able to use the nave as their parish church and the tower was built to hang the bells. So when the priory was dissolved in the sixteenth century St James' church was already the centre of a flourishing parish.

The parish kept growing and in the second half of the nineteenth century it was found necessary to enlarge the interior of the church. There were dire warnings that the whole building would tumble down if anything was disturbed but the north aisle was successfully rebuilt. During these renovations it was discovered

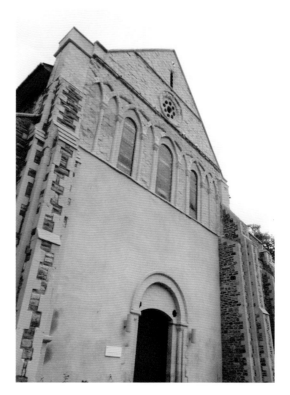

The Norman west front of
St James' Priory.

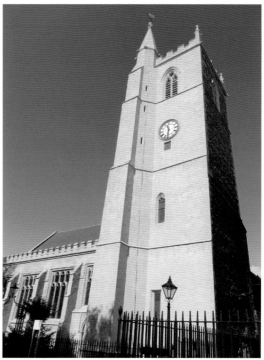

The fourteenth-century tower of
St James.

that the old flying buttresses were composed of portions of sixteenth-century tombstones.

The churchyard now contains a few gravestones and the base of the old cross but was originally very large. St James' Fair was held here each September, when people poured into the area to buy and sell livestock, pottery, clothing and other goods. In fact there were so many strangers around that it was considered a time of possible danger to the locals. In 1626, when there was fear of a foreign invasion, the number of armed night watchmen was stepped up for the duration of the fair. On the other hand travel for those attending could be risky and in 1577 some sailors stole a boat and robbed those who were sailing back home from the fair, though these pirates were caught and hanged at Canon's Marsh.

By the nineteenth century people were increasingly attracted to the fair to enjoy the amusements on offer in the booths. One of the largest booths built was in 1824 – the temporarily constructed Crown & Anchor Tavern, which measured 300 foot by 45 foot. According to the newspaper report the nightly masquerades were attended by 2,000 revellers dressed as friars and lawyers, clowns, pilgrims, fishwomen etc., while outside 'a goodly collection of thieves and ruffians were actively employed'.

It was the mixture of riotousness, violence and crime that led to complaints that it was sacrilegious to hold such an event in a churchyard. In 1838 the council reported that the number of merchants attending had dwindled to four clothiers, a couple of cutlers, a few china, earthenware and glassware sellers and some toymakers. They claimed that the fair was a nuisance, a source of evil, with disgusting scenes of profaneness, drunkenness and debauchery, so unanimously banned it for ever. The churchyard was reduced in size and part was paved over to become the Haymarket.

35. The Red Lodge

Bristol's mediaeval walls had been encircled by religious communities and with the Reformation their land was sold off by the Crown. Sir John Young, a wealthy merchant, built the Red Lodge on part of the old sloping gardens of the Grey Friars, though he died in 1589 and never saw its fine carved staircase and panelled rooms completed.

When it came up for sale in the 1850s its glory days seemed to have long gone. It had passed through several hands and had undergone some substantial alteration. Rooms were dark, the cellars were stuffed with rubbish, the door keys had been lost and a human foot was found in an outhouse. The Red Lodge was purchased for Mary Carpenter with the help of Lady Byron for use as a girls' reformatory.

Mary was the daughter of the Non-conformist minister of Lewin's Mead Chapel, which was next to an area of notorious slums. Houses were not fit for human habitation, there was drunkenness and destitution and children turned into pickpockets, burglars and thieves.

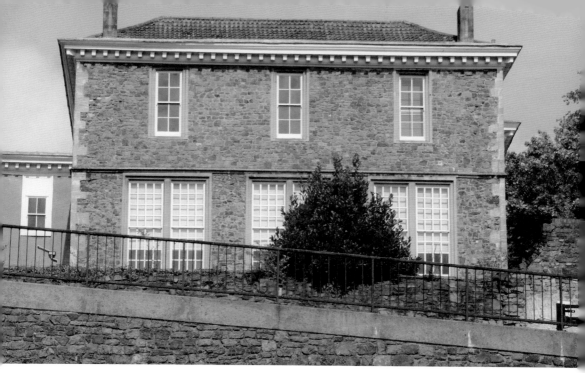

The Red Lodge seen from Trenchard Street.

Faced with such graphic evidence, she became concerned with the welfare of the poor and in particular of how early neglect and lack of education led children into delinquency. She had taught at her mother's boarding school and also worked as a governess, so she set up a ragged school in Lewin's Mead, later followed by a night school as well, which attracted a large and often noisy attendance.

In 1852 she established a reformatory school for boys and girls in Kingswood, as an alternative to sending young criminals to gaol. She thought it was vital to provide them with a more protected environment and prepare them to earn a respectable living. They were generally sent to the school by parents and relatives and the school had no official status or funding.

Her experience at Kingswood had persuaded her that a separate girls' school would be preferable. Only seven of the original twenty-seven girls who entered the Park Row School were able to read and write on admission. Two years later, that number had increased to twenty-one. They were allowed toys and dolls as well as books, for she felt that play was important. She often found and paid for lodgings for those whose time at the reformatory had ended.

Mary Carpenter's ideas, writings and work were influential. She addressed conferences and wrote letters, discussing her beliefs and methods. Industrial Schools Acts were passed in the mid-nineteenth century and the Elementary Education Act in 1870. She even travelled to India several times.

The school at the Red Lodge continued until 1919. Then the building was purchased for the Corporation of Bristol and after 1948 became a part of the Museum. The interior, with fine panelling, ornate wood carving and decorative plasterwork is a rare Bristol survivor in the face of so many odds.

This is an example of the fine wooden panelling to be found in the Red Lodge.

36. Former Christopher Thomas Works, Broad Plain

The railway propelled Bristol into a highly industrial age and fields were replaced by factories, each a powerhouse of activity manned by hundreds of workers. In 1784 there had been about 2,600 families in the district and a hundred years later the population had risen to over 50,000 people. This area around St Philips was called a gloomy vale, enshrouded in smoke where chemical products gave off nauseous gases into the already stench-laden and smut-thickened folds of air. Some companies that set up here were more successful than others and failure caused great hardship for the workforce.

At the end of the nineteenth century, the author of the book *Greater Bristol* remarked on the 'striking edifice' of Messrs Christopher Thomas & Bros' soap and candle works. It was described as a vast labyrinth of buildings containing an incredible amount of powerful machinery. Eight great boilers supplying the power to the engines were fed hundreds of tons of coal a week by grimy stokers. The clinker was tipped into chutes that emptied into carts in the streets outside, ready to be carried away.

Striking it might have been but far from sweet-smelling as tallow, generally from mutton, was a basic ingredient. To manufacture the soap, the tallow and caustic soda were run along troughs into huge copper vats where they were boiled together then later poured into large iron frames to cool, creating blocks of twelve hundredweight each. These were then cut or pressed into the required shapes for either bar, block, cake or ball soap.

From strong cloth soap used for wool scouring to those with names like Fine Brown Windsor, Golden Glycerine, Marble and Fine Honey, not to mention the institutional carbolic, all kinds then passed through the packing rooms.

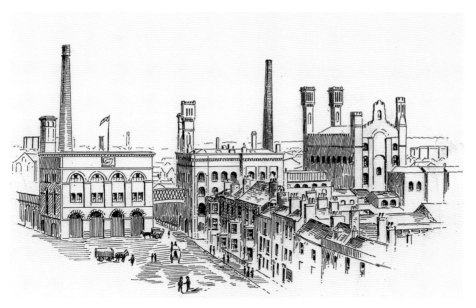

Christopher Thomas Works, Broad Plain in its heyday (Bristol Reference Library).

Nineteenth-century
Thomas' warehouse,
(shown at left in drawing
above) now used as a
department store.

Old factory section of Christopher
Thomas Works.

The wooden boxes, stamped with the firm's trade mark of an Assyrian winged
bull, were constructed out of Norwegian timber by box-making machines on
site at the factory.

Soap-making was a very old Bristol industry and the origins of the firm went back
to the mid-eighteenth century, although the Thomas family came in around seventy
years after that. It was they who altered the original works and in 1882 erected the
unusual towers to disguise the factory chimneys, apparently inspired by a Florentine
palace. The building in Straight Street is less overpowering and was a warehouse.

Tallow candles were replaced by those made from paraffin and self-consuming
wicks ended the need for snuffers but however much they improved, sales dropped
with the spread of first gas and then electric lighting. Soap-making was carried on
here until the 1950s, though in 1915 the company was taken over by Lever Bros.
The buildings are now occupied by Gardiner Haskins department store.

37. Victoria Street

In 1900, Victoria Street was described as a magnificent entrance to the city. It
had taken a long time to get to that state, for as soon as Temple Meads station
was built, people had begun demanding a decent road to connect it to Bristol
Bridge. In fact as early as 1837, when members of the Town Council were asking
the public for ideas for improvements and alterations to give better facilities and
invigorate trade, this road was one of the suggestions put forward, but then never
acted upon when the station was completed.

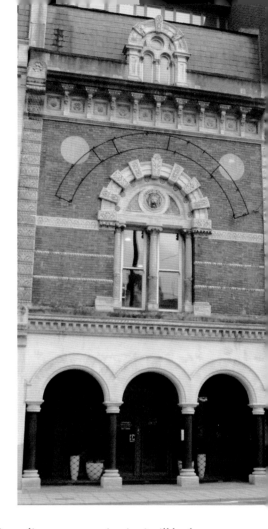

No. 16 Victoria Street premises today.

In 1852 complaints were made that 'commodious direct communication' still had not been provided and the traffic continued to wend its way along the narrow, dirty Temple Street and Thomas Street. There were discussions as to whether it would be better to widen those two streets rather than build a new one but eventually after years of debate and prevarication, the new road opened to traffic in July 1870.

A month later the plots of land with frontages on this now prestigious and well-frequented thoroughfare went on sale and a large crowd attended the auction. The first six plots went to Mr Morgan, a builder, but after that there was some strong competition and others got a look in. The buildings had to be completed by December 1871 and it was stipulated that all frontages were to be of brick and it was desired that the elevation of the buildings be in character with one another.

The Bristol blitz put paid to a lot of Victoria Street but there were ambitious plans to rebuild it. A 1947 guide to Bristol stated 'Victoria Street is to be planned as Bristol's shop-window. There, the visitor will pass display windows showing what the industries and crafts of Bristol have to offer.' Unfortunately it didn't work out that way. Bristol moved from manufacturing to service and financial industries which did not need display windows and, when rebuilt, Victoria Street gradually became a place of large offices.

A few of the original buildings remain, close to Bristol Bridge, showing the Bristol Byzantine style of the 1870s, though with some ground floor alterations made a century later. No. 16 is of brick and terracotta dressings with a slate mansard roof and David Stodhart Oliver had it built as the business premises of his wine merchant company. Mr Oliver owned prize-winning bulldogs, one of which, called Monarch, became national champion. Perhaps it should have been a bulldog's head rather than a lion's that decorates the façade.

38. Underfall Pump House, Cumberland Road

The Floating Harbour had been hailed as a great success but the Avon's mud once more started to cause problems. After some years a layer of silt, enriched by sewage, began building up in the enclosed space. Brunel, approached for a remedy, came up with the idea of the Underfall at the overfall dam, where the river had been dammed. Here a trunk or fenced passage was formed through which rapid currents of water could be passed into low level culverts, thus sucking out the mud at the lowest depths of the harbour. To augment this Brunel recommended the practice of continual dredging carried out for many years by a drag boat, which scraped up the mud.

The Docks Company appointed their first Superintendent of Works in 1843. The land behind the dam was shored up and reclaimed to be utilised by the company for a yard with a slipway, workshops and the superintendent's office. Because of its position it became known as the Underfall Yard.

The Engine House at the Underfall Yard, constructed of red Cattybrook brick.

Engine House machinery.

In 1888 the Docks Engineer, J. W. Girdlestone, erected a massive red brick engine house at the yard. This was to supply hydraulic power for the dock gate machinery and bridges at Cumberland Basin and also for the grain elevators and distributing machinery, capstans and turntables required at the new granary at Prince's Wharf as well as opening and closing Prince's Street Bridge. This was a great advance as it would provide a central place of service and maintenance staff under the immediate supervision of the Docks Engineer.

The towering building was of a high standard set in the middle of new workshops for carpenters, joiners, blacksmiths and fitters, as well as a new office for the Docks Engineer. Unfortunately, despite his achievements, the Docks Committee considered Mr Girdlestone had been too extravagant in the works he had carried out and censured him for 'carrying out undertakings without the previous sanction of the board'. His position became untenable and he resigned.

A newspaper report in August 1890 commented that it was always the lot of the public servant to have to give way. They showed their sympathy towards Mr Girdlestone by printing a long letter from him detailing the reasons for the expenditure and his grievances against the Docks Committee who had tried to keep everything about the matter as quiet as possible. His actions, he said, had been due 'to a deep conviction that all I did would eventually prove to be in the direct interest both of the committee and of the ratepayers'.

The Underfall Yard became near derelict in the later twentieth century and in the 1990s a Trust was set up to successfully restore it. It is now run as a working boatyard.

Underfall Yard buildings.

39. Clare Street

Clare Street, linking Corn Street with Broad Quay was started in 1770, after the removal of St Leonard's Church. It was named after eighteenth-century Bristol MP Lord Clare. These original houses were designed by Thomas Paty but as the Victorian era progressed, in the central area of the city rose grandiose banks, company headquarters, insurance offices and other commercial premises. Architects were influenced by the High Renaissance style, bringing florid Italianate and French ornateness to the narrow streets.

In 1881, after years of complaints about the 'narrow and tortuous streets' of central Bristol, another thoroughfare was pushed through by widening and extending the original Baldwin Street and taking it on to the quay. Charles F. Hansom designed No. 2 Clare Street on the corner site at the junction with the new Baldwin Street for Messrs Glass & Co. According to the *Bristol Mercury* newspaper, this now 'added to the street architecture of Bristol a building which for purity of style and artistic taste equals, if not surpasses anything of the kind erected in the city in recent years'.

When the building opened its doors on 17 December 1881, the newspaper reported fulsomely that it blended 'the solidity of former times with the lightness and elegance of modern times'. The description continued 'it has three fronts, supported by handsome columns of Mansfield Stone with carved caps and red

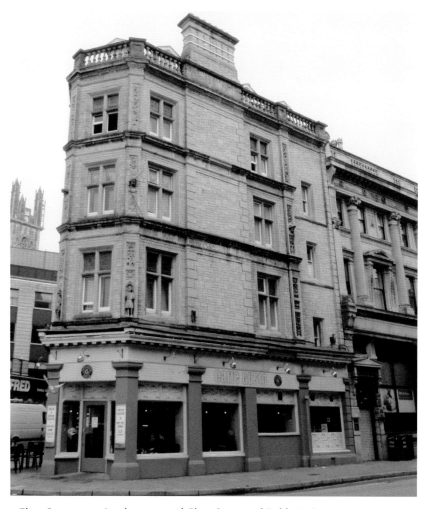

No. 2 Clare Street occupies the corner of Clare Street and Baldwin Street.

granite bases and above the fascia the elevation is broken by richly carved pilasters
and moulded string courses surmounted by a handsome cornice'.

The carving was by Mr Sheppard of Paul Street, St Paul's and the two figures
and busts showed among others a Virginian planter, Sir Walter Raleigh, a trader,
a sea captain and a distinctive Native American to reflect that Messrs Glass were
tobacco manufacturers and importers. Over the years No. 2 Clare Street gained
the name of Glass's Corner. In 1956 Pleasance & Harper, watchmakers and
jewellers, relocated here, calling it the Ring Centre. With the twenty-first century,
they too have gone and a café occupies the ground floor.

Now paved and banned to motorised traffic, Clare Street is a well-used
pedestrian corridor. So often only the modern shop fronts at ground-floor level
catch the eye and there is not the incentive to look upwards. It is worth pausing
for a moment to appreciate these ornate reminders of the Victorian age.

A detail of the carving showing a Native American.

40. E Shed, now Watershed

Since the 1830s there had been complaints that the trade of Bristol was falling behind as it lost out to other ports. A new dock at Avonmouth was opened in 1877, with facilities suitable for the larger vessels and eliminating the need to navigate the bends in the river. Looking at the City Docks, it was decided to make some changes.

The Drawbridge, which crossed the water between Broad Quay and St Augustine's Parade, was declared a nuisance to road traffic, having to be raised and lowered for the passage of boats. Surely it would be better to have a fixed bridge and culvert the section of the Frome that lay above the bridge, critically described as 'that abominable stretch of stagnant water that has long since lived its day'. Instead there could be a paved walk with trees and statues called Colston

The Watershed entrance with
the weekend market.

Avenue and a tramway centre for the new mode of transport, which carried people
to and from the suburbs.

Then there was the wharf constructed at Canon's Marsh and transit sheds were to
be erected. This would mean that the northern end of a shed would be conspicuously
visible to people walking across the new bridge, travelling to the Cathedral and Park
Street. It called for something architectural, not industrial which 'might become an
eyesore'. On 23 February 1893 Bristol Docks Committee invited designs for the
north end of the proposed two-storey transit shed E and boundary wall, offering a
fee of twenty-five guineas to the architect whose design was selected. As this had to
be submitted not later than 14 March, there wasn't much time to prepare.

Edward Gabriel's winning design is a triumph of ornate flourishes, using
Cattybrook red wire-cut facing bricks and dressings of Ham Hill stone. The
elaborate sculptured pediment featuring back to back buxom ladies in classical
flimsies was carried out by Gilbert Seale. With its octagonal domed turret, E Shed
creates a fine silhouette but is shown at its best in the afternoon and the area is
entered by what was described as a handsome gateway and ornamental iron gates.

The shed was fitted with hydraulic cranes, which travelled in front of the
shed, to land cargoes from the ships. At the back there were doors with hoists so
that wagons to carry away the goods could be easily loaded. The upper floor is

The view as you turn the corner towards College Green.

supported by steel girders resting on stone columns and this provides a covered walkway.

After the shed became redundant, Watershed Media Centre opened there in 1982 as Britain's first media centre, a cultural and creative hub holding events, festivals and workshops, with its three cinemas, conference rooms and amenities occupying the first floor of the shed. On the ground floor are Bristol Tourist Information Centre, restaurants, cafés and bars and a weekend market is held, taking advantage of the covered walkway area.

41. Tobacco Bond Warehouses

Tobacco became big business in Bristol. James I had raged against the use of the 'noxious weed' and for some time London had a monopoly on importing it, but in 1638 Bristol was allowed in on the act. Thirty years later half of the total shipping tonnage of the port was engaged in carrying tobacco from the Americas.

However, some tobacco was being successfully grown in Gloucestershire from plants brought into the country and this was very much disliked by the Bristol merchants, who saw it as a possible threat to their lucrative trade. More importantly, the Crown received taxes from imported goods, which they wanted

to keep coming into the coffers, so the English growers were fined and crops were destroyed, though it took until the end of the seventeenth century before the illegal tobacco fields were completely wiped out.

As so many hogshead casks of leaf were imported, manufacturing companies started up in Bristol. They were quite small to begin with, working in premises in the centre of the city. Cut tobacco which was prepared by removing the stem and rib of the leaf and then sliced into strips before drying and rubbing through sieves, was smoked in clay pipes. There was a flourishing pipe industry in Bristol too. Roll tobacco used the whole leaf and was spun into lengths of different thickness and given interesting names like Thin Coil Pigtail and Black Twist or Plug and Nailrod, which were used for chewing.

By the time H. O. Wills became a partner in Wills, Watkins & Co. in 1786, the American War of Independence was over and some machinery was available to help the manufacturing process along. There was a kind of bobbin machine for roll tobacco and a knife machine for the cut tobacco. As the company grew they moved into bigger premises in Redcliffe Street and in 1886 into specially built factories in Bedminster with much more sophisticated machinery and a large workforce. Cigarettes were an important part of the production line. Most were made by machine and each machine was turning out half a million per week.

W. D. & H. O. Wills later merged with several other British tobacco companies to found the Imperial Tobacco Co. Cargoes of tobacco in the twentieth century came to Bristol not only from America, but also Canada, Greece, India, southern Africa and Turkey.

The bonded warehouses were built by the corporation at Cumberland Basin at the beginning of the twentieth century, when the trade was at its height, to store tobacco under Customs supervision until required at factories. A and B stand close

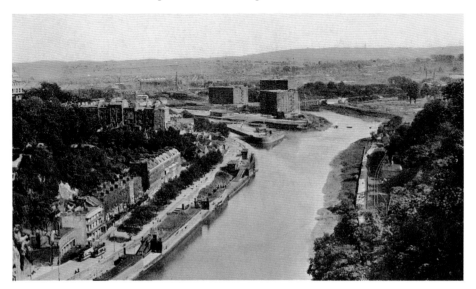

An early twentieth-century view from the Suspension Bridge shows the tobacco bond warehouses.

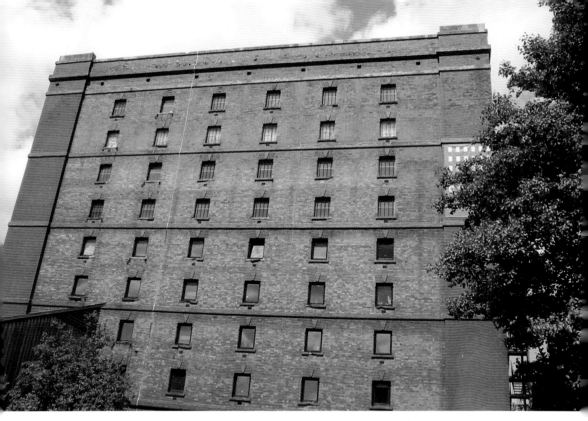

One of the former tobacco bond warehouses, now used for other purposes.

together, nine storeys of forbidding and uncompromising solid red brick. They look identical outside but, as you will see if you visit Bristol Record Office and the Create Centre, which are now housed there instead of tobacco, B comprises reinforced concrete inside, an up and coming idea at the time.

42. Edward Everard Printworks

The 1870 Education Act established a system of school boards of which Bristol was one, providing elementary school education for children and thus teaching them to read and write. Shops, companies and places of entertainment were now able to advertise their wares to a wide audience. At the end of the nineteenth century posters were everywhere, plastered over the walls of the city, vying for the attention of passers-by.

Edward Everard's stock in trade may have been posters, tabulated lists, reports and balance sheets, illustrated catalogues and trade circulars, but according to the *Western Daily Press* newspaper he identified himself with the better class of Bristol printers. His edition of *King Arthur's Wood* by Elizabeth Stanhope Forbes, of the Newlyn artists group, not only showed off the special typeface he had designed for it, but used a fine felt paper and a sackcloth cover to mark it out as something different from just a children's book. Even his promotional brochures could be

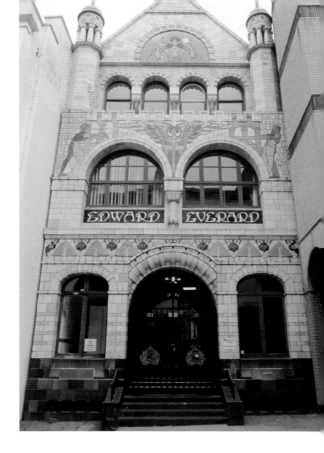

Frontage of former Edward Everard
Printing Works.

far from utilitarian. The 1902 *A 20th Century Palace*, for the Piccadilly Hotel in London, was printed on a special matt paper, so the half-tone illustrations of the capital city stood out clearly.

His printing house in Broad Street was something very different too. Thousands visited when it was first built at the beginning of the twentieth century, to gaze on 'an architectural creation embodying colour with design, a fifteenth-century building laminated with slab mosaics built in the reign of Edward VII'. It was stated that, 'the façade probably attracted more attention and elicited more criticism, complimentary or otherwise than any other building recently erected in Bristol'.

Designed by W. J. Neatby of Doulton Ceramics, the colour slabs differ from ordinary painted tiles in that they are intensely loaded with colour. Reflecting the printing business carried on in the building, Gutenberg, inventor of the movable-type printing press is depicted on the left-hand side with an example of his typeface and William Morris, the founder of the Arts and Crafts movement on the right. The winged Spirit of Literature is represented in the centre. On the gable is a female figure symbolising light and truth.

But not all the show was at the front. The architect, Henry Williams, made the sides and the back of the building striking, though less colourful, in terracotta and a dramatic dragon waterspout clings high on the wall in narrow John Street. The sides are lost, as in the 1970s National Westminster Bank incorporated the front and rear elevations in their new offices.

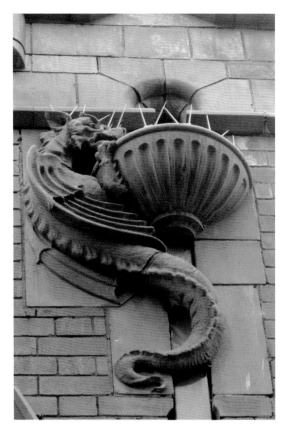

Dragon spout on rear of Edward Everard building.

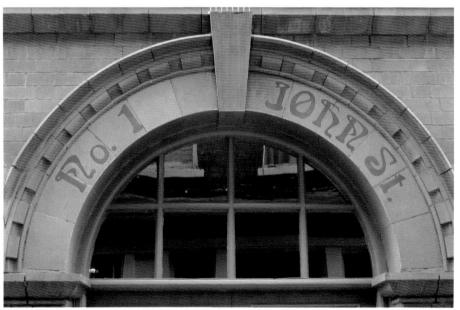

Address on rear of Edward Everard building.

43. The Leadworks

In 1850 a letter writer to the newspaper signing himself 'a stifled voice from the centre of smoky Bristol', complained that the misery shopkeepers had been doomed to suffer was intolerable. This misery was described by another as noxious gases emanating from the very great number of manufacturing chimneys vomiting dense black clouds. Chimneys got taller in the effort to disperse the smoke and fumes higher in the atmosphere.

Rowe Brothers' Leadworks with its tall brick chimney, built in the 1880s on Canon's Marsh, is described in Pevsner's Architectural Guides as typical industrial. Canon's Marsh, once a grassy meadow between the Cathedral and the water had certainly changed by the late nineteenth century. There were gas works, warehouses, transit sheds and even railway lines to carry goods to and fro. No one would have believed that a hundred years later all this activity could have been swept away.

The City Docks trade was reduced, the goods yard closed in 1965 and it looked a gloomy, dismal place. The gas works ceased production, the company removing the roofs of some buildings. Rowe Brothers moved out and dereliction set in. In the 1970s with the official end of the City Docks the area was used for car parking by city centre workers.

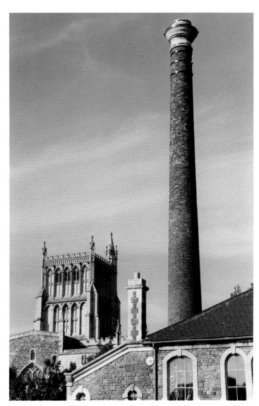

Leadworks chimney with Cathedral in background.

Leadworks – Anchor Square façade.

What eventually came was a multi-million-pound regeneration scheme, aiming to bring a range of commercial, resident and leisure activity to the area. It was seen as important to keep it being a part of the city rather than having the discouraging aridity of shopping centres and trading estates where no one lived and everything went dead at the end of the working day. Integral was the idea of new traffic-less public spaces where people could walk and sit and events could take place.

Millennium Square features polished-steel water sculptures, which delight children, and a series of statues which are extremely approachable. There is also the popular At-Bristol hands-on Science Centre, created from a 1904 Hennibique system goods shed. The old Rowe Brothers lead-rolling building was refurbished and converted into a restaurant; it stands in Anchor Square.

The emergence of Harbourside was not without many problems and controversy. Some of the residential developments may not be as aesthetically successful as they could have been but the area has emerged from desolation and has taken its place as a vibrant part of Bristol.

44. Wills Memorial Tower

In the 1870s there was an increasing awareness of the need for scientific and technical education. The Bristol Medical School was looking to establish a College of Science around the same time that Dr Percival, headmaster of Clifton College, published a pamphlet stating that universities should be provided in large towns. Through public meetings support was gradually obtained and money donated for the opening of university facilities in Bristol. As a result, University College, Bristol

opened in October 1876 occupying rented premises that somehow managed to accommodate 500 students.

It was a temporary solution. The architect C. W. Hansom designed a range of buildings in Stapleton stone with Bath stone dressings, which were erected in what was known as Tyndall's Park. The first section of this was opened in 1880, the eastern side in 1883. There were large and small lecture rooms, an examination hall and separate common rooms for male and female students. After endowments had been made at the beginning of the twentieth century, the charter for an actual University of Bristol was awarded on 24 May 1909.

The Wills Memorial Tower stands at the top of Park Street, 215 feet tall, solid and grandiose. It was commissioned and paid for by sons of the first Chancellor of the University, Henry Overton Wills, in his memory. Designed by Sir George H. Oatley, it was officially opened by George V on 9 June 1925. It has been called the last great Gothic building in England and is frequently mistaken for a church by visitors seeing it from afar.

The tower is crowned by the Octagonal Lantern, an open structure designed to let the sonorous tones of its bell, Great George, flood the city with sound. The tower is home to a veritable tribe of carved heads which are an interesting collection. Among the grotesques you will find carvings of a helmeted soldier and members of the university staff.

Wills Memorial Tower on a pre-war postcard – not a car in sight.

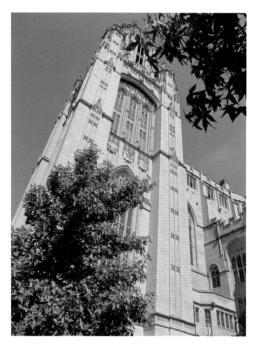

The Tower today, after cleaning.

In the base of the tower is the impressive Entrance Hall with its fan vaulting which is around seventy feet high and a double flight of stone steps leads to the oak-panelled Great Hall with its hammer-beam roof. Photographs taken of the hall after a devastating air raid show a tangle of girders resting on a carpet of ash and glass splinters, described as 'an abject ruin'. It was reconstructed post-war, with some of the wood carving of the original design omitted due to cost constraints but now the splendour is restored. Cleaning work on the outside of the tower took place in the early 2000s.

45. St Peter's Church

Nowadays St Peter's stands like a lone sentinel but in days gone by it was closely surrounded by houses, including one of the largest in the mediaeval town. The houses were destroyed and the church was gutted following enemy action by the Luftwaffe in 1940 when central Bristol was blitzed.

St Peter's is considered to be the oldest of the central Bristol churches, but the only parts of the original Norman structure to survive are the lower stages of the tower, which are over six feet thick. The rest of the building was considerably modified and added to in the early English and Perpendicular style. There were several small chapels dedicated to various saints and during the Middle Ages the interior of the building would have been brilliantly coloured and gilded. There were originally a large number of memorial brasses, though it was lamented that many had been stolen by the end of the nineteenth century.

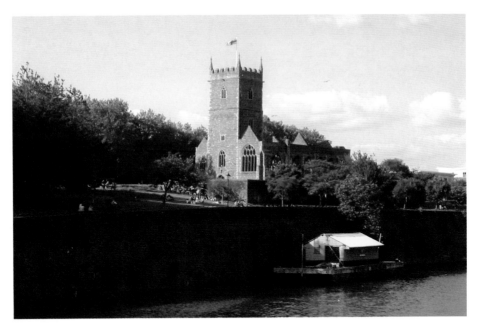

St Peter's and Castle Park from Bristol Bridge.

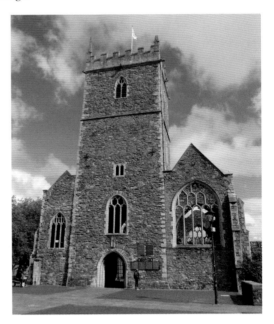

St Peter's from the west.

The most impressive of the tombs in the church, with carved panels and coloured effigies, was that of Robert Aldworth, a wealthy merchant and sugar refiner who died in 1634. He had rebuilt the house next to the church which, many years after his death, became a workhouse, named St Peter's Hospital. After the church was bombed the tomb was left in situ in the roofless building until 1958, when

Penny found near St Peter's
after the bombing raids.

an attempt to remove it resulted in it falling to pieces. The fragments were taken into the care of the museum, to join some rescued carvings from the ruined timber exterior of St Peter's Hospital.

When the hail of bombs rained down on the evening of Sunday 24 November 1940, whole streets disappeared. A strong wind carried the devastation across the centre of the city, spreading sheets of flame and clouds of black oily smoke and leaving heaps of rubble and gaping holes punctured by the skeletons of smouldering buildings. There were other large-scale night raids during the winter, one lasting twelve hours from dusk to dawn with the weather so cold that the water from the firemen's hoses froze.

Bristol suffered many bombing attacks of varying intensity during the war years, which not only destroyed and badly damaged public buildings, schools, churches, hospitals, factories, business premises, cinemas and houses, but killed hundreds of ordinary people. In 2008 a bronze plaque memorial was erected on St Peter's, inscribed with the names of those civilians and auxiliary personnel killed in Bristol during the Blitz.

46. The Council House (City Hall)

College Green was spruced up in the mid-eighteenth century, when the area was raised, fenced and planted to become the sort of place where you could promenade along the paths beneath the trees. The old High Cross had been moved here from the central crossroads of the city, where it was deemed to be a dangerous obstruction, but was then taken down again as those who came to promenade on

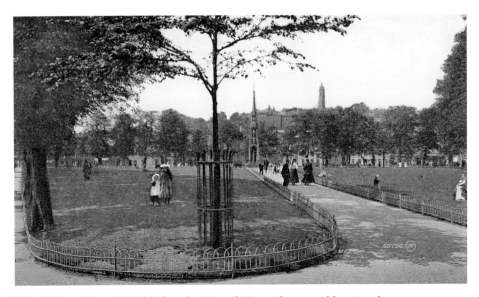

How College Green looked before the Council House, from an old postcard.

the green complained it was an obstruction there. Stored in the cathedral, it was scandalously given away by the Dean to Henry Hoare to decorate his Stourhead estate in Wiltshire. Eventually a replica was commissioned and installed with great ceremony on the Green in 1851.

College Green became a flat open space in the twentieth century because of the new Council House built here to replace the old one in Corn Street. Not that the old one was particularly ancient, being completed in 1829, but although extensions and additions were made, by the end of the century it was being ridiculed as being gaol-like, dilapidated and inadequate. In 1919 the corporation bought up properties on two sides of College Green in order to demolish them and give the city a new, more suitable municipal building.

Vincent Harris was appointed architect in 1933 but the Second World War intervened and caused a considerable delay in progress. In fact it took until 1956 to actually bring the building properly into use. Crescent-shaped and of neo-Georgian design with a central entrance, it has been described as chilly and aloof, while others were less polite and called it ugly with a monkey temple portico. There is no central access from the green to the main entrance, as this is blocked by the moat and the wall behind it, hinting at dominance rather than democracy.

There were supposed to be huge naked sculptures on the fountains in front of each end pavilion, which were considered wildly inappropriate so close to the cathedral and instead the rather drab circular concrete stumps squirt a feeble flow a few inches into the air. But everyone liked the golden unicorns which came as a great surprise to prance on the roof.

What upset a large number of people, however, was the demand by the autocratic architect to lower College Green, which he said would 'make my building'. The High Cross, Queen Victoria's statue, tall trees, pleasant avenues,

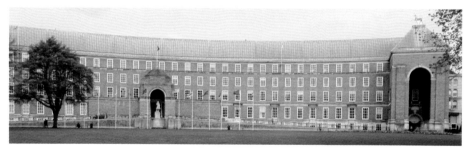

The Council House (City Hall) from College Green.

all had to go, leaving a billiard table finish, or as critics put it 'a wasteland of flat lawns and aimless paths'. Now, years later, with the growth of new trees and the addition of a corner flower bed, the effect has been softened and people enjoy using the open space that is the modern College Green.

The building was designed at a time when there was a growth in municipal administration and in fact there were concerns not long after it was completed that it wouldn't be large enough. The change in the way such administration is carried out in the twenty-first century is now bringing around changes in the interior of the renamed City Hall but the view of the pale brown brick exterior remains as a monument to twentieth century ambition and insensitivity.

47. Spike Island

The tea trade to Bristol had developed considerably post-war, with supplies coming from India, Pakistan and Ceylon, as it then was. A special warehouse was allocated at Avonmouth for weighing and sampling but the Brooke Bond warehouse in the City Docks was built in 1960 for blending and packing. It was designed by Beard, Bennett, Wilkins & Partners and its square functionality was a far cry from the art deco cinemas of senior partner J. Stanley Beard's early career.

Brooke Bond was originally a Manchester company, established in the last quarter of the nineteenth century. The firm expanded so successfully that by the 1950s it supplied about one third of the world's tea. The logo of two leaves and a bud was seen on packets in kitchens everywhere and production capacity of the Bristol packing factory when first opened was 360,000 lbs of tea a week.

A two-storey building, the blending process was done upstairs, then the tea passed down chutes to the ground floor where it was packed in an assembly hall that had a translucent barrel vault roof comprising 4,000 hollow glass blocks. The design won a Civic Trust commendation.

The decision to close the City Docks was taken just a few years after the warehouse was built. A Parliamentary Bill set out to not only withdraw navigational rights but also to fill in large sections of the Floating Harbour and construct new motorways with a multi-level junction. A protest started and swelled and the Bristol City Docks Group was formed. The interest grew in what

Spike Island on Cumberland Road.

could be achieved by using the Docks as a feature of Bristol's community life. Housing developments burgeoned, one being at Baltic Wharf.

Due to takeovers and mergers, the Brooke Bond warehouse closed in 1990 and became dilapidated. So what to do with a building constructed for a specific purpose? The answer came in a group of Bristol-based painters, sculptors and printmakers who had been using a nearby warehouse, which had to be vacated because of redevelopment.

Their number had grown considerably over the years and the Brooke Bond building would offer space for 100 artists plus other art-related activities. Having secured one of the first major awards from the National Lottery in 1998, conversion of the building was begun. Spike Island set about becoming an 'international centre for the development of contemporary art and design'.

Unlike Bristol's Victorian warehouses, this building comes across as unassuming and so simple that you might pass by without really noticing it. But well-lit and flexible, it serves as a perfect foil for the art created and exhibited inside its walls.

48. Radisson Blu Hotel

Development on a large scale took place during the 1960s and '70s when a tide of buildings seemed to engulf Bristol, setting out to provide office space in the most

unimaginative form. As this development was seen as vital, planning requirements were not too rigorous. The result was a series of glass and concrete boxes.

One of these was the late 1960s eighteen-storey Bristol & West Tower on Broad Quay, which replaced older office premises. It gave the building society's employees a splendid view but overpowered the Centre. Although described in newspaper reports as strikingly handsome, shapely and elegant, doing much to enhance the Centre skyline, and praised in architectural circles for its avant garde appearance, many Bristolians considered it ugly and intrusive.

There were moves afoot in Bristol from 1961 to install a series of concrete decks twenty feet above the ground, so that pedestrians could walk from College Green to Broadmead without encountering traffic, although probably the system was more for the sake of free movement of the traffic than the pedestrians' safety. New buildings erected between the Centre and Broadmead would be required to have these decks incorporated. The first stage would have passed above the Centre and a landing place was duly put in place at the first floor level of the banking hall of the Bristol & West building.

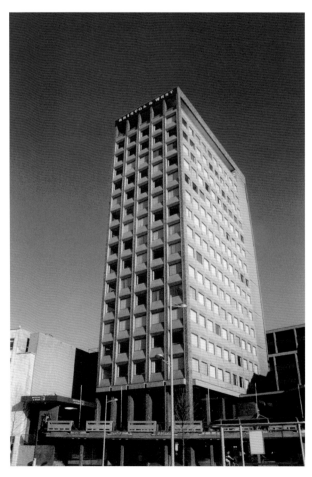

The old Bristol & West tower.

Although fragments of this ambitious scheme were implemented, with promises of ramps and escalators, plus cafes and shops at this higher level, it never actually took off. Developers were not keen on the added expense they would incur, it was not an aesthetic proposal and people objected to being forced up on to windswept bridges. The property market collapse of the mid-1970s put the last nail in the coffin.

Over the years the Bristol & West Tower's granite-chipped concrete became drab. The building society was taken over and staff moved to new offices, leaving only the car park in use. By the beginning of the twenty-first century there were calls for the tower to be demolished, but somehow it clung on. In 2005, Bristol City Council granted detailed planning consent for the conversion and transformation of the building.

Transformation was the correct word as the tower was re-clad in glass panels in different shades of blue, with darker glass nearer the ground and lighter panels towards the top, which gives the impression that the tower is merging into the sky. The Radisson Blu Hotel development also comprises residential apartments and retail and restaurant units.

The age of the large office block in the city centre shuddered to a close. It is interesting to note that fifty years ago this part of the city was earmarked as strictly commercial and not considered an appropriate place for residence. Many of

The twenty-first century
Radisson Blu Hotel.

the central office blocks built in the twentieth century now face the future as apartments, the new area of development.

49. The Spectrum Building

The M32 slicing its way into the city was all about accessibility. This Bristol Parkway was part of a programme of road building 'designed to allow vehicles to move freely and without hindrance'. No more winding through narrow lanes and city streets when traffic could speed to and from the M4 on the new Parkway. It brought drastic changes to communities and wide approach roads as effective as city walls.

It was stated that the provision of such roads was closely linked with the development of the city and its future prosperity, much like the arguments for the railways of the previous century. The first stage which passed through open, more rural land including the lower slopes of Purdown, was opened on 18 July 1970. The final section from Muller Road, Eastville, to Ashley Road/ Newfoundland Road came into use in May 1975.

The Parkway trampled into the city on stilts. It swept uncaringly against the existing domestic architecture. Streets were chopped in half, all the houses along the north side of Stapleton Road, from Muller Road to Eastville Junction were demolished. The 58-feet-high viaduct called the Thirteen Arches was blown up, the last remains of the Baptist Mills brass works were destroyed and the map was

The front of the Spectrum Building.

changed to attract and accommodate the new development which it was hoped would then result.

When the Spectrum project at the end of the new road was initially proposed by developers, it was intended that this office building should be brick clad. But what emerged in 1984 was something quite different – more controversially futuristic but low in height. The fact that it was kept down to five storeys, then a step to three storeys towards Pembroke Street and Gloucester Street, meant it did not overwhelm.

Being clad in blue-mirrored glass, it reflected the nearby Georgian buildings of surrounding streets, helping it to blend in. The landscaped courtyard brought

Spectrum Building –
reflecting the old houses.

a softening of the stark lines so often seen on a modern building and broke up the bulk.

What people probably remember most about the Spectrum Building is the blue gleam, somewhat less visible now the trees have grown and hide more of it from view. As for the M32, it's really difficult to imagine being without it.

50. Horizon House

All change can certainly apply to the part of Deanery Road opposite the Central Library. The nineteenth century had brought a viaduct over College Street with its Georgian houses. Building the new Council House led to the demolition of these properties, providing space for car parking facilities and the construction in 1958 of Cabot House, the offices for Bristol Council Planning Department. Cabot House, designed by the city architect, in spite of its array of windows always gave the impression of glowering rather darkly down on intended visitors.

The Planning Department later moved into nearby Brunel House, leaving Cabot House empty and boarded up for over ten years from the early 1990s. When Cabot House was finally demolished in 2008, an archaeological survey was carried out and cellars and basements of old buildings that had been in College Street and adjacent roads were discovered.

Horizon House, the 6,595 square metre office building by Alec French Architects, occupied by the Environment Agency's head office in Bristol is part

Cabot House.

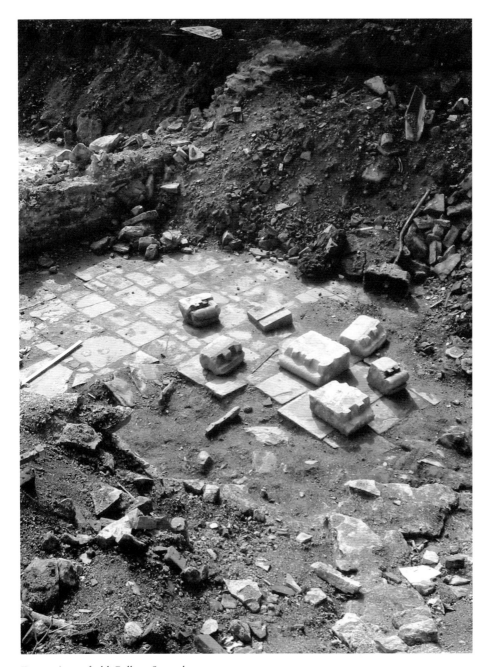

Excavations of old College Street houses.

of a mixed use scheme which has replaced Cabot House. A green glazed entrance on Deanery Road sets out its credentials and inside there is a five-storey atrium. Over 85 per cent of the material from the buildings demolished to make way for Horizon House was recycled in the construction of the new building. Eco-friendly

Horizon House.

features include ground-source heat pump rainwater harvesting and recycling plus a roof terrace garden.

Horizon House was awarded the 2010 Best BREEAM (Building Research Establishment's Environmental Appraisal Method) Office award for its environmental credentials. If Bristol is to be judged by its buildings, this is a flagship that sets a high standard.